LOST
NORTHERN
KENTUCKY

LOST
NORTHERN
KENTUCKY

ROBERT SCHRAGE
& DAVID E. SCHROEDER

THE
History
PRESS

Published by The History Press
Charleston, SC
www.historypress.net

First published 2018

Manufactured in the United States

ISBN 9781625859822

Library of Congress Control Number: 2018932099

To Richard Schrage, who would have turned one hundred years old in 2017.
Thanks for still being an inspiration in my life.
and
Ed F. Schroeder, who taught me about loyalty to community and dedication to
public service.

CONTENTS

ACKNOWLEDGEMENTS

The authors wish to thank Cierra Earl and Garry Collum of the Kenton County Public Library for their assistance with photographs and Dr. Paul A. Tenkotte and Dr. James Claypool for their foundational work in Northern Kentucky history. Thank you Ann Schrage, Kevin Kelly and Matt Becher for your help and support. A final thank-you goes to Kaitlin Barber, Bridget Striker and Hilary Delaney from the Boone County Library for their photographic and informational assistance.

INTRODUCTION

One of the great pleasures of history is to uncover something long lost to time. Northern Kentucky is filled with such history that defines who we are today. Unfortunately, much of this history that stood right in front of our ancestors' eyes is gone. It is either a distant memory to those who witnessed it or, to others, an introduction to its existence and impact on the region. In Northern Kentucky, so much lies in ruins or in the dustbin of history. Nevertheless, it is important. As Abram Joseph Ryan said, "A land without ruins is a land without memories—a land without memories is a land without history."

As we know, Northern Kentucky is the most northern part of the commonwealth of Kentucky, and Boone, Campbell and Kenton Counties make up the vast majority of the population. Historically, this population has been of German and Irish heritage, starting before Kentucky became a state. The first Germans came from the south and later via the Ohio River. The Irish came in segments, first the mostly Protestant Scots Irish and then Irish Catholics. The immigration of these groups impacted the history and development of Northern Kentucky perhaps more than any other single factor. The other great influence on the region is the Ohio River, which not only helped immigration but also the settlement and growth of the first communities, including Covington and Newport, whose foundations date to the 1700s. Other river towns developed from Campbell County in the east to Boone County in the west. Many, such as Silver Grove, Dayton, Bellevue, Newport, Covington and Ludlow, still exist. Other towns have been lost to

history. For example, in Boone County, Constance, Taylorsport, North Bend, Touseytown and East Bend have disappeared. In Kenton and Campbell Counties, many cities were established and remain incorporated to this day.

The estimated population of the three northern counties, according to the Tri-County Economic Development Corporation, is 384,700. Many of these people are new to the area with no real knowledge of the history of the region, especially the history lost to development and progress. Still others, mostly older, remember the great historic structures that dotted the landscape. This book serves as an opportunity for new residents to learn about the tremendous history lost over the years but still a large part of who we are as a community. For long-term residents, it is a trip down memory lane—an opportunity to reminisce about times gone by.

This book will focus on history lost in Northern Kentucky in business and industry, religious structures, schools and civic buildings, recreation and residences. While there are so many structures in these categories lost to history, there are also success stories where buildings have been saved. It would not do history justice without talking about some of the saved buildings. They represent great history that through reuse are right before our eyes and their historic grandeur still present. Unfortunately, much has been lost, including great churches such as Saint Aloysius and Madison Avenue Presbyterian in Covington and Marydale in Boone County. Other lost history includes the beaches of Dayton and Bellevue, hospitals like Speers and beautiful civic buildings such as the Covington City Hall and the old federal building. Beverly Hills Supper Club, Lookout House, Bavarian Brewery and Wiedemann Brewery are excellent examples of lost businesses and industry.

There are many choices to make in writing a book of this nature. Not everything is included. However, if the reader has experienced these structures in person, it is hoped they can relive the memory. If the reader has never seen the structures, hopefully these pages bring the excitement of a first trip. More than anything, it is desired that by reliving this history, we can come to better appreciate our past. As a result, maybe we can save some of the existing, but threatened buildings for future generations.

1
BUSINESS AND INDUSTRY

WIEDEMANN BREWERY

George Wiedemann was born in Eisenach, Germany, in 1833 and immigrated to the United States around 1853. He moved to Newport, Kentucky, in 1870 and founded the George Wiedemann Brewing Company. It became one of the largest brewing companies in the nation and the largest in Kentucky. A major expansion of Wiedemann's brewing operations took place in the 1880s when he developed five acres of land at Sixth and Columbia Streets in Newport. Designed by architect Charles Vogel, it became, according to the *Encyclopedia of Northern Kentucky*, "one of the world's largest and most efficient breweries."

The Wiedemann Brewery structure became one of the most iconic and popular buildings in Northern Kentucky history. This was in part due to its magnificent size for a brewery of its time, the fame of the Wiedemann name, the popularity of the beer and its place in Northern Kentucky lore and the popularity of the old beer garden in the twentieth century. The brewery was five stories tall and included a stable that could house 150 horses. In 1893, the famous Samuel Hannaford and Sons architectural firm designed the beautiful and ornate Wiedemann offices. The brewery consisted of many iconic components, such as the curved corner, boiler and engine rooms, storage cellars, racking and wash house, main office, bottling shop, storage and garage complex, tower, stacks and brew house.

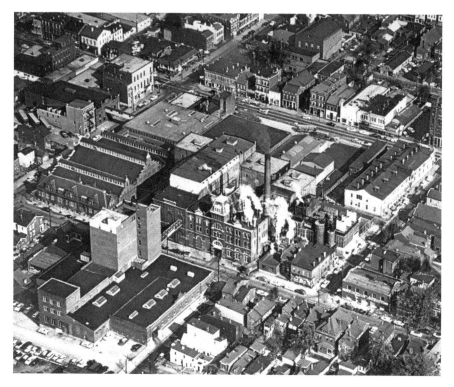

Aerial view of Wiedemann Brewery. *Kenton County Public Library.*

Wiedemann Brewery continued to grow and eventually was taken over by Wiedemann's sons Charles and George Jr. However, the federal government shut the brewery down during Prohibition. Before the brewery was shut down, the federal government charged it with violation of the Volstead Act for producing 1.5 million gallons of illegal beer. The grand buildings were actually padlocked, and George Wiedemann's grandson Carl served time in a federal penitentiary over the illegal brewing. It reopened following repeal and did very well for the next thirty years. Wiedemann kept up on technology and had the first steel fermenting tanks west of Pittsburgh in 1946. By 1967, the annual capacity stood at 900,000 barrels. However, the market changed. The number of breweries in the region went from twenty-six in 1898 to four by 1967.[1] The G. Heilman Brewing Company bought Wiedemann in 1967 and closed the plant in 1983. Wiedemann ceased its independent operation after ninety-seven years. In part, the Newport plant became less efficient. There was a certain amount of pride in the community with the Wiedemann Brewery business, as well as the structure itself. Newport and Wiedemann

Beer garden at Wiedemann Brewery. *Kenton County Public Library.*

went together; their identities were closely aligned. As the brewery was the largest employer in Newport, the city lost four hundred jobs and an eighth of its payroll tax revenue. The water department lost $100,000 in revenue.[2] With this loss, Newport no longer housed the last large brewery in Northern Kentucky. It symbolized a need for the community to revitalize itself—which residents successfully did over the next couple decades. The entire structure was demolished in the 1990s, and today, part of the land is used to house the Campbell County Justice Center. It continues to live in the memory of many Northern Kentuckians who can remember the grand buildings that operated during their lifetimes. There were efforts to save the structures, and the city was awarded a federal grant to convert them to an office and retail complex. Unfortunately, those plans fell through. Even though a distant memory, the Wiedemann Brewery Complex stands as a symbol of the region's strong brewing tradition and industrial innovation.

LOOKOUT HOUSE

The Lookout House was one of the great nightclubs in Northern Kentucky—with a past as interesting as it is historical. Dave Schrage, who parked cars at the Lookout House, recalls the time Tiny Tim's limousine pulled under the large roofed carport. The carport was the main attraction of the front view of the supper club's exterior. All parking was valet, and Schrage remembers the extreme perfume smell as he parked Tiny Tim's limousine.

Known for its dinners, night life and gambling, the Lookout House was located on the corner of Kyles Lane and Dixie Highway in Fort Wright, Kentucky. In 1886, Aloise Hampel bought the land and opened a restaurant known for its tremendous views of Northern Kentucky and Cincinnati. As a result, it was renamed the Lookout House, but many falsely believed it was named because of its history as a lookout site for Union troops during the Civil War. Following Hampel's death, Bill Hill bought the restaurant in 1912. Hill turned it into a flourishing nightclub. However, Prohibition caused the business to struggle. As a result, Hill sold it to Jimmy Brink, who made changes such as major remodeling and bringing live entertainment and gambling to the Lookout House. The rest is history, as they say. Since gambling was illegal, numerous charges were brought against Brink. Several high-stakes gamblers frequented the club, as well as, purportedly, members of organized crime. Brink was killed in a plane crash in 1952. It was suspicious according to the court. Brink was killed with Charles Drahmann, and both had recently testified before a federal panel investigating gambling nationwide.[3] The Lookout House was sold in 1962 to Bob and Dick Schilling. The club did very well under the Schillings' management, and famous entertainers came from around the country. One advertisement for the Lookout House, found on nkyviews. com, describes the supper club as "a focal point for the smart set from the mid-west area. Here, one can enjoy dining in a most magnificent manner. Our main dining room is the Casino Room. It will comfortably seat 500 guests, there are six other dining rooms serving the finest American foods and featuring nightly entertainment. There are also 15 other private rooms, seating from ten to 500." Total seating capacity was said to be 1,800 guests. In 1970, Dick Schilling told Wayne Dammert, "I've taken this place about as far as it's gonna go." A month before, he purchased the site of the Beverly Hills Supper Club.[4]

On August 14, 1973, tragedy struck the Lookout House while it was closed for renovation. A thirteen-year-old Robert Schrage, standing on

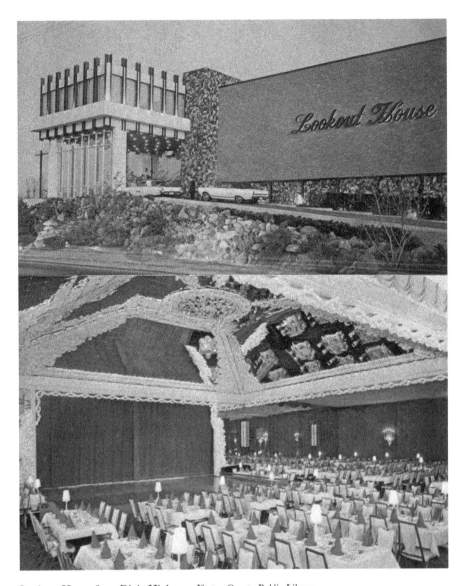

Lookout House from Dixie Highway. *Kenton County Public Library*.

Vidot Court in Fort Wright, watched as the blaze dominated the view up the hill. The heavy smoke was engulfing the sky. With it went the building where so many Northern Kentucky residents and visitors enjoyed great food and national entertainment. Later in the year, Robert Schrage snuck into the ruins of the structure and noticed the remnants of the ornate hallway and some of the beauty of the entranceway could still be seen. It

was rumored a grease fire in the kitchen started the blaze, and the *Kentucky Post* described it as "one of the most dramatic fires in local history."

The Lookout House was never rebuilt. Today, an office building and bank occupy the site.

Beverly Hills Supper Club

The Beverly Hills Supper Club has two dramatic histories. First, it is the site of a famous nightclub known across the country as a spot for top-notch entertainment and excellent food. Second, it is the location of one of the most tragic fires in U.S. history.

Located just a few miles from downtown Cincinnati, the site of the former Beverly Hills Supper Club is a sad reminder of the tragedy that took place on the hill overlooking Southgate. The fire is indelibly imprinted into the memories of anyone alive at the time, especially the responders and the families of those lost.

The club began in the 1930s as a restaurant and gambling hall. Gambling is a major part of the Northern Kentucky entertainment history, and Beverly Hills was a major player. While illegal, it was a protected industry, especially by a syndicate mob. However, in 1961, George Ratterman was elected sheriff of Campbell County. He ran on a reform platform of cleaning up the small towns of Northern Kentucky. Organized crime eventually left, business suffered and the Beverly Hills Club closed. In 1969, the club was sold to Dick Schilling and his sons. Major renovation took place to reconfigure the site. According to the *Encyclopedia of Northern Kentucky*, a ground floor was constructed, the second floor remodeled, the casino turned into the Viennese Room and space converted into a show room and large banquet halls. In 1970, fire destroyed the interior of the building, and the Schillings started over again. After reconstruction, the building as it is remembered today was opened in 1971. In 1972, Schilling redesigned the front façade. The business thrived, and additions were constructed for the first six years of the decade. The most famous rooms were the Zebra, Viennese and Cabaret. The final addition to the building was the Garden Room. It was behind the club and overlooked the gardens. The building renovations created a "sprawling, non-linear complex of function rooms and service areas."[5]

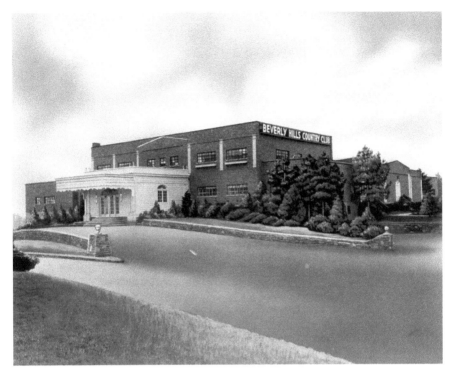

Exterior view of Beverly Hills Country Club. *Kenton County Public Library.*

Tragedy Strikes

May 28, 1977, is a date most longtime Northern Kentuckians will never forget. Singer and actor John Davidson was to perform in the Cabaret Room, which could hold 600 safely.[6] Estimates by the fire marshal put the room above capacity, later estimated at 900[7] to 1,300.[8] A wedding reception party complained of excessive heat and left the Zebra Room early, and the space remained vacant until just before 9:00 p.m., when a worker opened the door to discover smoke. It quickly spread to other rooms and throughout the building. "Fire investigators later estimated that, once through the northern doors of the Zebra Room, the fire took only two to five minutes to arrive at the Cabaret Room; as a result, news of the fire and the first of the smoke and flame reached the Cabaret Room, the farthest point from the Zebra Room, nearly simultaneously."[9] Fire responders arrived quickly, and around 9:10 p.m., the lights went out, causing panic. When all was said and done, 165 people died in the Beverly Hills Supper Club fire. According to the

Cincinnati Enquirer, the investigation found many construction deficiencies, including overcrowding, inadequate fire exits, faulty wiring, lack of firewalls, poor construction, safety code violations and poor regulatory oversight.[10]

The impact of the fire was tremendous in so many ways—perhaps none more important than the many governmental code and safety improvements that resulted. Today, the site sits vacant, resting on top of a hill overlooking I-471 and U.S. 27. Only some concrete remnants on the driveway remain. A state historical marker has been installed. On the sad hill, a large cross honors the deceased. It can be seen when driving on I-471.

THE LIBERTY THEATER

In Covington, like many urban centers of the early part of the twentieth century, citizens had several choices for movie going. The growth of movie theaters paralleled the growth of the film industry, especially from silent to talking pictures. According to Robert Webster in "A History of Northern Kentucky's Long Forgotten Neighborhood Movie Theaters," "[L]ive entertainment shows were the rage well into the early 1920s. Silent movies were first introduced in the late 1800s, but received little notice until the early 1900s when improved technology provided that they could be produced on a single reel." The first movie theater in Covington was opened in 1905 on the north side of Pike and Craig Streets. Covington had four grand movie viewing options in the 1920s and '30s. They included the Lyric Theater at 714 Madison, the Rialto (once called the Colonial and opened around 1916) at 425 Madison, the Strand on Pike Street and the Liberty between Sixth and Pike Streets.[11] By 1920, over thirty movie theaters existed in Covington, Newport, Bellevue and Dayton.

Designed by architect Harry Hake, the Liberty Theater opened on July 21, 1923. Construction costs were estimated at $300,000, and the auditorium featured 1,500 blue leather seats on both the main floor and balcony. The theater also included a marble lobby and had a famous miniature Statue of Liberty. Other features were ticket booths made of mahogany, a grand staircase made of marble and brass, a large organ and a large mural of New York Harbor on the stage.[12] The Liberty was financed by some important Covington businessmen: Richard Ernst, George Hill, Polk Laffoon, Frank Thorpe and L.B. Wilson. The theater was so named because it was adjacent to the new Liberty National Bank. One comment

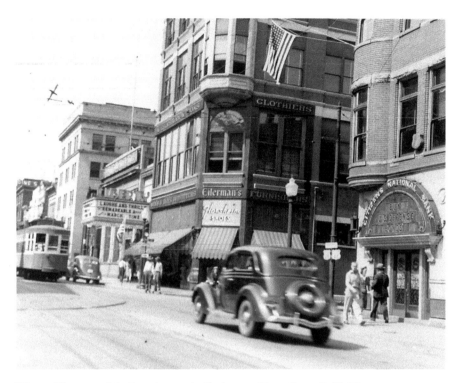

Liberty Theater on Madison Avenue in Covington. *Kenton County Public Library.*

on the website Cinema Treasurers offers memories that "the Liberty had a huge selection of candies, sodas, and sandwiches and even the rest rooms were elaborate, it looked as though the rest room area itself was fit for a queen, I remember it being huge, lounging chairs & couches lining the sprawling lower level that housed it, down a luxurious sprawling staircase, rather scary and cold to a child yet inviting with its intrigue." According to Webster, the Liberty Theater "was by far the most elegant theater building in the entire Northern Kentucky Region."

With Covington being a shopping hub of Northern Kentucky until the 1960s, parents would drop their kids off at the Liberty while they visited the department stores. The Liberty Theater closed in the 1970s. During this time, Covington saw a decline in downtown businesses. Movie theaters were also victims of the flight to the suburbs. "Long-term Covington businesses closed: Eilerman's in 1973, Goldsmiths in 1966, and later Coppins, Marx, J.C. Penny, Montgomery Ward, Woolworth's, and Sears."[13] Neighborhood movie theaters are now a thing of the past. The popularity of television paralleled the decline of the neighborhood theaters beginning in the late

1960s and early 1970s.[14] The only one still operating as an entertainment venue is the Madison Theater in Covington, which is mostly opened for concerts. The Liberty Theater was bought by Mid-States Theaters Inc., which also bought the nearby Madison. The Liberty closed in the 1970s, and the structure was demolished by Peoples Liberty Bank for an office addition.[15]

PETERSBURG DISTILLERY

The Reverend John Tanner established Tanner's Station in an area of rural Boone County now called Petersburg. Petersburg is on the site of a Fort Ancient village from approximately AD 1200. Petersburg developed rapidly over the years, and in 1859, it had the largest population in Boone County.[16] The town sits on a beautiful high bank of the Ohio River, providing not only protection from flooding but great commercial and recreational access as well.

Prosperity and growth began in the 1830s with the establishment of the Petersburg Distillery. The location of the distillery was at first the home of the Petersburg Steam Mill Company, founded in 1816. However, in 1833, the company was sold to two brothers, William and John Snyder. They quickly added a distillery, and according to Bridget Striker, Boone County Library historian, it "became an economic powerhouse in the region." In 1860, the distillery was producing approximately 1.125 million gallons of whiskey per year.[17] Snyder's whiskey and flour were transported by the Ohio River. Despite this success, William Snyder fell on hard financial times and could not repay loans received to grow the business. Snyder sold the distillery, and his son-in-law Colonel William Appleton took over management. However, according to Striker, the Civil War and high excise taxes forced him to sell, and in 1864, 75 percent of the interest was sold to two individuals: Joseph Jenkins (50 percent) and James Gaff (25 percent). Ownership changed again with both Jenkins and Gaff selling their interests to Julius Freiberg and Levi Workman.

The whiskey industry prospered in the years to come, and the Petersburg Distillery did very well through the remainder of the century. By 1880, the Petersburg Distillery was producing more whiskey than any other in the state of Kentucky. The distillery was worth $250,000 and had a capacity of four million gallons per year; the daily capacity of twelve thousand gallons was

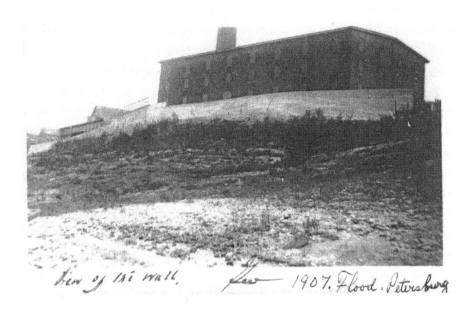

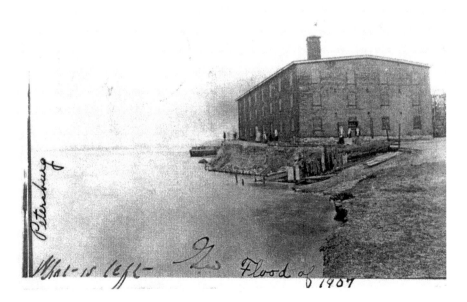

The Petersburg Distillery. *Kenton County Public Library*.

14 percent higher than the average Kentucky distillery in 1890.[18] In 1899, the distillery was sold to the Kentucky Distilleries and Warehouse Company, which was buying like businesses across the state. The company started shutting down distilleries, and Petersburg survived until 1910. For the next few years, the distillery was used as a warehouse in order to distribute the remaining whiskey.

The buildings were dismantled. The site today has remnants of foundations, stone and walls. Three buildings remain: the distillery cooperage (on distillery site, circa 1870), the distillery scales office (circa 1859) and the superintendent's office. According to the *Encyclopedia of Northern Kentucky*, "[T]he massive brick warehouses were dismantled one by one. Much of the brick was reused in construction projects outside Boone County. However, a number of buildings in Petersburg were built from distillery brick, including the tiny 1916 Petersburg Jail. Along with several houses, the National Register lists the 1913 Odd Fellows Hall and the 1916 Petersburg Baptist Church, also built of distillery brick."

The Altamont Springs Hotel

The City of Fort Thomas was originally incorporated on February 27, 1867, under the name the District of Highlands. It was later incorporated as Fort Thomas in 1914. The beautiful city has a long and interesting history that includes Native American battles, military barracks, interesting historic figures and a retreat location. According to Sam Shelton, in an article on ftthomasmatters.com, "[T]he district of Highlands started taking shape. [Samuel] Bigstaff kept his promise of bringing his electric street cars that ran from Newport to the District of Highlands. This once desolate place started attracting people from around the area and people started moving in, building large estates. The surrounding land became a retreat for the rich and famous wanting to escape from the bustling, crowded river cities." An area called the Midway District began developing near the site of the military fort, which began construction in 1883. These barracks were moved from Newport, where they were prone to flooding. By 1893, forty-nine buildings had been constructed at the new fort. The Midway District, according to Shelton, was made up of bars, restaurants, ice cream shops and prostitution.

However, an often overlooked part of the history of Fort Thomas is the development of hotels. The first was the Fort Thomas Hotel on South Fort

Thomas Avenue. The most well known was the Altamont Springs Hotel. People would travel long distances because they believed its springs were beneficial to their health. While this belief helped make the hotel popular and successful, it may have led to its downfall. Once it was proven the springs had no health benefits, people stopped visiting. The Altamont sat on the current site of Crown Point, with a beautiful view of the Ohio River. The hotel was eventually sold to the army for the wounded and later had a few other owners. According to Shelton, "[A]fter going through several owners, the Altamont met its final match- the wrecking ball. All remains of the hotel were pushed over the hillside. To this day you can walk along the old road and stairs that once lead from the Ohio River to the famous hotel."

SOUTHERN RAILROAD DEPOT AT LUDLOW

The history of railroads is as much a part of Northern Kentucky as anything. It is a fascinating narrative that parallels the growth and development of the entire Northern Kentucky region. The most heartfelt aspect of the railroads

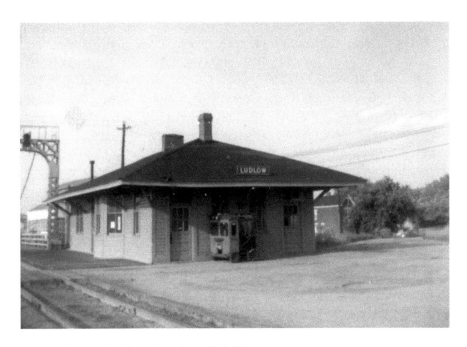

Southern Depot at Ludlow. *Kenton County Public Library.*

to the people was the depots. Railroad depots dotted the Northern Kentucky landscape, facilitating arrivals and departures. They were also used to deliver shipments to the community and functioned as a place to get news through the Western Union telegraphs. People left via the depots to search for their fortune or fight in a war. Many came back through the depot in a casket, arriving in their hometowns for a final time. So many emotional goodbyes and hellos took place at Northern Kentucky railroad depots, which served as unofficial town centers. The station was in many regards the most important building in town. Residents' emotional responses toward the loss of local depots could be felt. In Boone County, depots existed in Devon, Kensington, Richwood and Walton—which had both the Southern Railroad and Louisville and Nashville. Campbell County had depots in Bellevue, Brent, California, Dayton, Mentor, Newport, New Richmond and Ross. In Kenton County, there were as many as fourteen.

Both authors grew up in the railroad town of Ludlow, Kentucky, and its depot is a good representation of the many serving the region. As in other communities, the railroad had a tremendous impact on Ludlow. Even though Ludlow was an urban community, it had a rural feel. The railroad hired hundreds of people, and the population of Ludlow grew from 817 in 1870 to 2,469 in 1890. Many of them were Irish and German immigrants who came to work on the railroad. Businesses and industries opened operations to take advantage of the railroad location.[19] Today, only a few of the railroad depots exist. Beginning in the 1960s, there was less need for depots. For example, shipments could be transported by other means, such as trucks. The railroads were aggressive at tearing down these historic structures, mainly for economic reasons, such as not paying real estate taxes to local communities. Two that have been saved are in Erlanger and Covington.

Discontinuation of passenger service in Ludlow was announced by the Southern Railroad in 1968. The Ludlow Depot was eventually demolished after almost one hundred years of service. Even now, decades later, current and former residents talk about the old depot, and its emotional bind still exists. This can be said of all railroad communities across Northern Kentucky. These depots hold a special place in the hearts of railroad towns.

BIG BONE SPRINGS HOTEL

The national significance of Big Bone Lick cannot be overstated. It was discovered by Europeans in the early 1700s, and today

> *Big Bone Lick is a unique state park showcasing the remains of some of America's most intriguing Ice Age Megafauna. Once covered with swamps, the land that makes up Big Bone Lick featured a combination of odorous minerals and saline water that animals found difficult to resist. For centuries great beasts of the Pleistocene era came to the swampy land in what is now known as Northern Kentucky to feed. Animals that frequented Big Bone Lick included bison, both the ancient and the modern variety; primitive horses, giant mammoths and mastodons, the enormous stag-moose, and the ground sloth.[20]*

The earliest people can be traced to around 13,000 BC (Pre-Paleo period) to AD 1000 (Late Woodland period). For thousands of years, they hunted the big game that couldn't resist the mineral and salt springs. The site became an archaeological and paleontological treasure.

According to Hillary Delaney, a researcher and historian with the Boone County Public Library, "The earliest documentation of a business established to cater to tourists in Big Bone dates to about 1815. The 'Clay House,' so named for Henry Clay, was positioned near the corner of what are now Beaver Road and Boat Dock Roads—A great spot, easily reached by stagecoach or river vessel." It began operation in 1815 and was immensely popular. During this time, many people came to the hotel for its health benefits; however, the area also attracted scientists to do research and/or gather bones.

In 1864, Cincinnati grocer Charles McLaughlin bought land at Big Bone with plans for a grand hotel and built a forty-room hotel and several cottages in 1873.

According to Delaney, there are indications "that two to three hotels were operating in the Big Bone Springs area concurrently: the larger Big Bone Springs Hotel and smaller ones." On May 29, 1869, the *Cincinnati Enquirer* reported,

> *[T]here probably never was a season when so many of our citizens have determined to leave the city for a more desirable locality as some of the watering places or at the sea-side shores, and from reports already received,*

these rural retreats are extensively patronized. The Big Bone Springs, Boone County, Kentucky, are now open for the reception of guests, and we have no hesitation in declaring that no place in the entire country can excel those springs for accommodation and comfort of its guests.

Bathers often frequented the springs for the healing benefits a good soak offered, and they were provided with the privacy and convenience of bathhouses built at near the source of the water.[21] At this point in history, the quickest route to the Springs Hotel was on the Ohio River. Generally, guests would arrive at Hamilton, about two miles from the hotel. McLaughlin would arrange transportation to the hotel.

McLaughlin ran the Big Bone Springs Hotel for three years and then went west, turning over management to family and others. According to the *Louisville Courier Journal* on November 19, 1899, "It was not long after leaving, before the hotel went down, the old-time guests dropped away and the place was closed." The hotel never reopened. In the 1899 article and interview with McLaughlin, he returned to the springs and lived with his family in one wing of the old hotel. "He is always ready to talk of the old days where things were not as they are now."

McLaughlin often found bones and amassed quite a collection. He later presented "a valuable collection to the Cincinnati Museum of Natural History."[22]

2
RELIGIOUS STRUCTURES

COVINGTON FIRST PRESBYTERIAN CHURCH

The Reverend William Orr came to Covington in May 1841 to open a school for young women; it became known as Orr's Female Academy. As his work progressed, he also began organizing a Presbyterian congregation in rented facilities on Madison Avenue. In November, fifteen charter members organized Covington's First Presbyterian Church under Orr's guidance. William Ernst, one of the first elders of the community, purchased a lot on Madison Avenue between Fourth and Fifth Streets and financed the construction of a small frame chapel measuring twenty-five by forty feet. The dedication of the chapel occurred on December 25, 1842.

Orr stepped down from his leadership role at First Presbyterian in 1844 to devote more time to his flourishing academy. At that time, the Reverend John Clark Bayless was named the congregation's second pastor. Bayless remained in Covington until 1854, when the Reverend John M. Worrall was named pastor. Worrall had great success in the city. In 1854, he organized the Second Presbyterian Church (later known as Madison Avenue Presbyterian) to accommodate the growing population living south of Eighth Street. Worrall was also primarily responsible for the construction of the beautiful new First Presbyterian Church on the north side of Fourth Street just west of Madison Avenue.

Covington grew quickly in the years following the Civil War. As a result, old, outdated churches were being torn down, and new magnificent churches

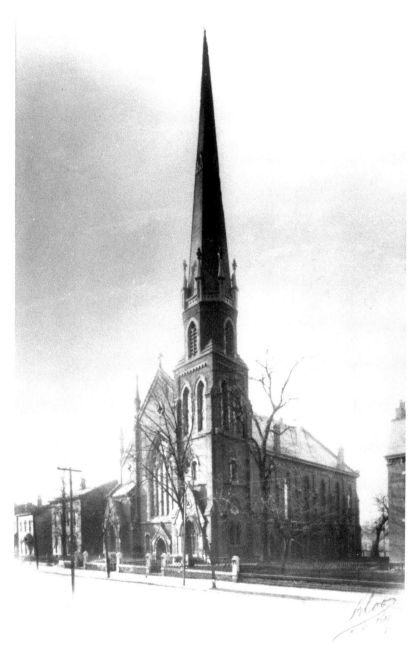

Covington's First Presbyterian Church on West Fourth Street with its original spire.
Kenton County Public Library.

were being constructed. There seemed to have been some competition between the denominations in the city to build the most beautiful church. Three major congregations, Mother of God, First Baptist and First Presbyterian, each chose the well-known firm of Walter and Stewart to design their churches in the early 1870s.

The Walter and Stewart design for First Presbyterian called for a red brick Gothic-style church with an asymmetrical façade. The east corner was anchored by a bell tower surmounted by a spire reaching 185 feet into the sky. Ground was broken for the building in 1871, and the church was completed and dedicated two years later in 1873 at the cost of over $86,000. Directly to the east, First Baptist Church also completed a new sanctuary in the same year.

First Presbyterian continued to grow along with the city. The congregation was socially active and began an industrial arts program for boys and girls of the city in 1914. The school taught classes in basket weaving, sewing and domestic arts. The congregation also sponsored a thriving Sunday school and religious societies for men and women.

The 1873 church remained intact for nearly sixty years. However, in 1930, it was determined that the building's spire was structurally unsound and needed to be removed. This drastically changed the appearance of the building and left a rather odd-looking, incomplete bell tower without a finial. The 1937 flood also contributed to the deterioration of the church. At the height of the flood, over five feet of water inundated the structure. The floors, woodwork and most of the furniture were destroyed. Replacement costs reached $4,000. The flood also had another unanticipated consequence. Many of the members of the congregation who lived near the church for decades began to move to higher ground to avoid frequent floods. As a result, membership declined. Despite these difficulties, the congregation persisted and, in 1941, remodeled the basement into a large assembly room and four classrooms.

The neighborhood surrounding First Presbyterian changed over the years from primarily residential to commercial. Membership plummeted as new Presbyterian churches in the suburbs flourished. This, coupled with the deteriorating condition of the church building, led the members to discuss relocating. On January 9, 1957, the congregation voted to purchase a plot of land on the Highland Pike in neighboring Fort Wright. On this site, the new First Presbyterian Church of Covington–Fort Wright was dedicated on September 17, 1961.

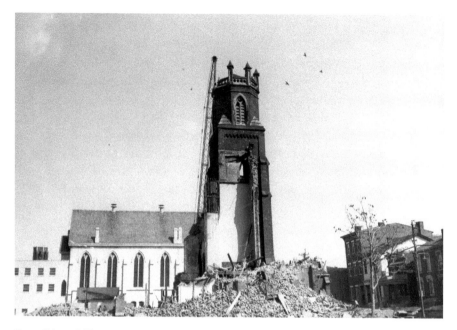

Demolition of First Presbyterian, 1964. *Kenton County Public Library.*

The last service conducted at the old building on Fourth Street was held on September 10, 1961. The building stood empty for a number of years until it was demolished to make way for the construction of the new Internal Revenue Service building. The venerable old building, nearly a century old, could not withstand changing demographics. The building succumbed to the wrecking ball in 1964.[23]

ST. PAUL UNITED CHURCH OF CHRIST (GERMAN EVANGELICAL)

Covington's west end attracted many German immigrants and their families in the nineteenth century. Among these were members of the German Evangelical movement. In the spring of 1847, a small group of German Protestants met to discuss the establishment of a German Evangelical Church. The enthusiastic group of thirty families decided to purchase a lot on the east side of Banklick Street at Eleventh Street to build a frame church and meeting room. The first services were held on

August 29, 1847, and the building was dedicated on November 1 of the same year under the patronage of Saint Paul.

St. Paul German Evangelical Church grew over the next several decades as more Germans filled the west end. In 1860, work began on the first floor of a new brick church on the original lot. This building housed both the worship space and the sanctuary. A permanent second-story sanctuary was added in 1867 and dedicated the following year. The congregation celebrated its silver anniversary with the installation of a new pulpit, altar and chandeliers in 1872. A beautiful set of stained-glass windows were set into place to mark the occasion. The exterior's final touch was the construction of a bell tower and spire in 1875. The bell was named in the memory of the nation's fallen president, Abraham Lincoln.

The church underwent other improvements over the years. In 1898, Frederick Brenner donated a $2,000 pipe organ to the congregation. The old organ was donated to the St. John congregation in West Covington. Two years later, a central heating system replaced the numerous coal stoves that heated the building for so many years. Electric lights replaced gas fixtures in 1913.

The German character of the congregation persisted for decades. St. Paul members refused to participate in several anti-saloon campaigns and held their services in the German language exclusively until 1912. In that year, they decided to have services in English and German every other week. The use of German was eventually dropped altogether during World War I.

The congregation continued to make improvements to the building over the years. An addition to the rear of the building was made to meet the needs of the growing Sunday school in 1922—the seventy-fifth anniversary of the parish. That year, membership stood at 350. Ten years later, the original steeple was removed and replaced by a copper one. Instead of a cross at the apex of the steeple, St. Paul's featured a copper hand with a finger pointing to heaven.

Like many churches in Covington, membership declined following World War II. Many members had relocated to the suburbs, and the neighborhood around the church was being filled with Appalachians seeking a better life in the urban areas in and around Cincinnati. The congregation decided to establish a building fund in 1957 to relocate the church. A seven-and-a-half-acre piece of property was purchased in suburban Fort Wright, and in 1967, construction began on the new St. Paul. The dedication of the new building occurred on February 9, 1969.

With the completion of the new church, the old building on Banklick Street was put up for sale. The nondenominational All New Temple purchased the building in 1971. The congregation used the building primarily as a storage space. Over the next two decades, the building deteriorated and became an eyesore in the neighborhood. In September 1990, neighbors discovered that the old St. Paul Church was on fire. The Covington Fire Department arrived on the scene quickly, but the building could not be saved. The steeple and several major walls collapsed. What was left of the structure was demolished in quick order. The fire was ruled suspicious in nature.[24]

Scott Street Methodist Church

Scott Street Methodist Church (formally Scott Street Methodist Episcopal Church South) enjoyed a long and interesting history in Covington. Methodists were among the first settlers of the city and had organized a congregation as early as 1827. In 1835, the congregation built a church on the 200 block of Garrard Street. The congregation grew quickly and constructed a new two-story brick Gothic Revival church on Scott Street between Fifth and Sixth Streets. The building contained classrooms and a meeting hall on the first floor and worship space on the second. The building cost $8,000, and the total funds needed were raised in a two-day campaign. At that time, the congregation became known as the Scott Street Methodist Episcopal Church.

The issue of slavery caused a major schism in many Protestant denominations in the United States leading up to the Civil War. In 1843, Methodism split with the creation of a new Methodist Episcopal Church South. In 1846, the members of Scott Street Church voted to join the new denomination. Twenty-seven members of the church who opposed slavery left the congregation and eventually established the Union Methodist Episcopal Church at the southwest corner of Greenup and Fifth Streets. The two Methodist congregations were physically separated by the alley running between Greenup and Scott Streets.

Scott Street Church continued to grow and expand. In 1878, the congregation started a new mission on Eleventh Street between Madison and Greenup. This congregation eventually relocated to a new church at the corner of Greenup and Eighteenth Street and became known as St. Luke

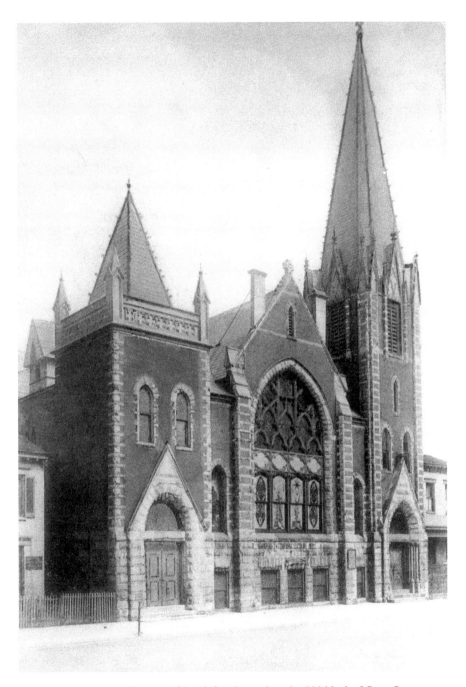

Scott Street Methodist Episcopal Church South stood on the 500 block of Scott Street, the present-day site of the Covington Branch of the Kenton County Public Library. *Kenton County Public Library.*

Methodist Episcopal Church South. The original church on Eleventh Street was bought by the Diocese of Covington and transformed into Covington Latin School.

Meanwhile, Scott Street Methodist Episcopal Church began plans for a new church to replace the 1843 structure. The Cincinnati firm of Crapsey and Brown was commissioned to design a larger Gothic Revival building in 1895. The result included a pleasing red brick and rough-cut stone façade with twin towers and a large central stained-glass window. Like the original building, the first floor housed classrooms and meeting spaces and the second floor a beautiful sanctuary with a seating capacity of over one thousand. Impressive ceremonies marked the dedication of the church in May 1896.

During the early years of the twentieth century, the congregation faced several challenges. In January 1904, the building suffered from severe damage due to a fire of undetermined origins. Among the items lost were several memorial windows and the pipe organ. The members rallied to restore the church.

The neighborhood became more commercial as time passed and membership declined. In 1928, the Scott Street Church South and St. Luke Church South decided to merge at the Scott Street site. The newly merged congregation was renamed First M.E. Church South. The merger, however, proved unsuccessful, and in 1930, many of the former St. Luke members withdrew.

Changes were also occurring on the national level. The Methodist Episcopal Church and the Methodist Episcopal Church South decided to merge in 1939. At that time, Union Methodist and First Methodist South also decided to merge at the Union Church on Greenup. The old Scott Street Church was initially leased to the First Church of the Nazarene. This congregation eventually purchased the building in 1944. The Nazarenes built a new church in Park Hills on the Dixie Highway in 1967. The Scott Street Church stood empty until 1970, when it was demolished to make way for the new Kenton County Public Library.[25]

MADISON AVENUE PRESBYTERIAN (SECOND PRESBYTERIAN)

In the decade preceding the Civil War, Covington's Presbyterian population grew precipitously. Members of First Presbyterian living in the southern

end of the city decided to establish the Covington Second Presbyterian Church on February 8, 1855, with twenty-nine charter members. Property was purchased on Ninth Street, and construction began on a new two-room building housing a lecture hall and classroom. This new church was dedicated on December 23, 1855. Six years later, the congregation financed a larger worship space as an addition to the original structure. Unfortunately, the entire property was heavily damaged in a fire in 1880. This building was sold to Methodists who established an African American congregation in the rebuilt space, and the members of Second Presbyterian began planning for a new substantial church building.

Second Presbyterian chose a new location to better serve the community on Madison Avenue near Ninth Street. The congregation built a Gothic Revival structure on the property and dedicated it in 1882. Around that time, the name of the congregation was officially changed to Madison Avenue Presbyterian. Members were only able to enjoy their new church for two years. Again, in 1884, a fire swept through the church, leaving the building in a pile of ruins. Undaunted, the members hired the firm of Crapsey and

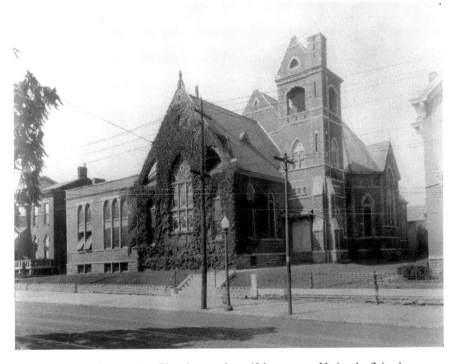

Madison Avenue Presbyterian Church was a beautiful structure. Notice the flying buttresses on the façade. *Kenton County Public Library*.

Brown to design a new Gothic Revival church. The new building featured a central stained-glass window flanked by decorative flying arches. The bell tower was set back from the façade on the north side of the church and was surmounted by a low-pitched pediment. On November 21, 1886, the first services were conducted in the new Madison Avenue church.

The congregation purchased a parsonage for their minister on Scott Street in 1914, but changes in the neighborhood were starting to take place that were having an impact on many Protestant churches in the city. Members were moving farther south in Covington or to the new suburbs south of the city. When a new parsonage was acquired in 1922, it was located on Audubon Road in neighboring Park Hills.

Despite losses in membership, the community remained dedicated to the church. In the 1920s, a large two-story brick addition was built to the south. The addition cost $30,000 to construct and included a kitchen, dining room and classrooms for the Sunday school. By this time, membership stood at about 300. Urban flight took its toll following World War II, and by 1959, membership stood at 221. Like many other congregations in Covington at the time, members began looking for other alternatives to practice their faith. In 1961, it was decided to merge Madison Avenue Presbyterian with Lakeside Presbyterian in the nearby suburb of Lakeside Park. The old Madison Avenue Church was eventually sold and demolished. The parking lot for Allison and Rose Funeral Home now occupies the site of the former ivy-strewn Gothic Revival church.[26]

St. Aloysius Church

In the early evening of May 16, 1985 (the Feast of the Ascension), St. Aloysius Roman Catholic Church was completely destroyed by fire due to a lightning strike. The fire not only consumed the structure but also closed the century-old church and one of the Diocese of Covington's most vibrant and historically significant church buildings.

St. Aloysius, or as the parishioners affectionately called it, St. A's, had its beginnings in 1864 when a group of parishioners at the rapidly growing Mother of God congregation met in a neighborhood grocery to discuss the establishment of a new parish. In the following year, a parcel of property was purchased at the southeast corner of Seventh and Bakewell Streets, and

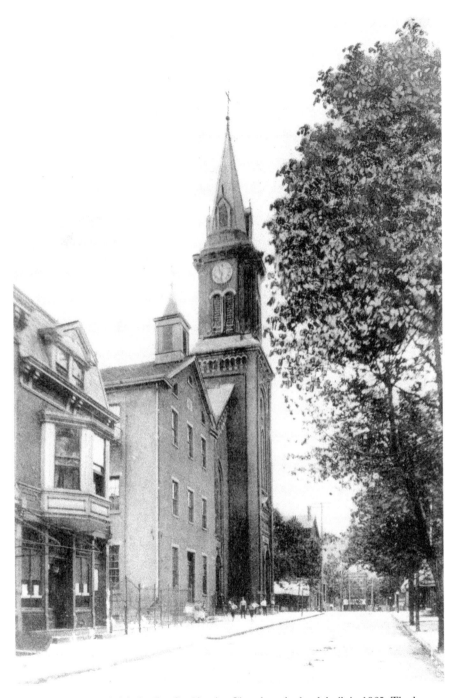

The building to the left is the first St. Aloysius Church and school, built in 1865. The larger church to the left was constructed two years later in 1867. *Kenton County Public Library*.

construction began on a three-story combination church and school. The new brick building was dedicated on September 17, 1865, and the school opened at the same time.

St. Aloysius Parish grew so quickly that the combination church and school building ran out of space within a few months. Plans for a new permanent church were acquired from local architect Louis Picket. The plans called for a Romanesque Revival church with a central bell tower topped by a Gothic spire. The interior provided space for many future stained-glass windows. Dedication ceremonies occurred on November 24, 1867. The building was 165 feet in length and measured 64 feet in width, making it one of the largest churches in Northern Kentucky at that time.

The German parish maintained stability through a series of long-term pastorates beginning with Father Joseph Blenke (1887–1907). Under Father Blenke's leadership, the parishioners built an undercroft in honor of Our Lady of Lourdes as a shrine in 1889. The shrine, or grotto as it became known, centered around a large fieldstone wall with a niche containing a beautiful image of Our Lady of Lourdes patterned on the famous shrine in Lourdes, France. Water from the French shrine was periodically shipped to Covington, and as a result, St. Aloysius Church became a popular place of pilgrimage for area Catholics. The shrine also featured two hand-carved wood statuary groups imported from Germany. One group depicted the first miracle at Lourdes and the other the Virgin Mary with the child Jesus, St. Dominic and St. Rita. In 1902, Pope Saint Pius X declared the grotto a national shrine.

During Father Blenke's tenure, St. Aloysius School blossomed. The original church and school was turned over totally for educational purposes when the new church was constructed. In the late 1880s, a second school was constructed behind this original structure. This new building allowed the classes to be separated by gender, which was common in large parish schools of the time. Father also arranged for the Sisters of St. Francis of Oldenburg, Indiana, to staff the school. Finally, in the mid 1890s, Blenke was responsible for installing two large stained-glass windows in the transept of the church and eight windows in the nave. By the time of Father Blenke's death in 1907, St. Aloysius was the largest parish in the Diocese of Covington, with 4,000 members and a parish school educating 784 children.

Father Blenke's successor, the Reverend Ignatius Ahman, left an indelible mark on the architecture of the church. Father Ahman commissioned Newport architect David Davis to redesign the exterior of the church. The old Gothic spire was removed and replaced by a new bell tower and a

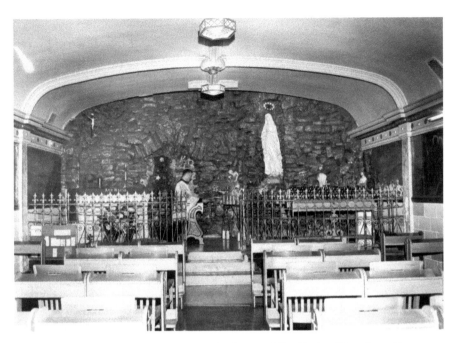

Father Raymond McClanahan praying in the Grotto of Our Lady of Lourdes at St. Aloysius Church. *Kenton County Public Library.*

graceful copper cupola. Finally, the exterior brickwork was faced with stone. All of this work was begun in 1911. In 1914, the parish turned its attention to beautifying the interior of the building. Additions included a new pipe organ, communion rail, frescos, twelve decorative pilasters on the side walls—one for each of the Apostles—and plaster arabesque work. By May 1915, the church was ready for the celebration of the golden anniversary of the parish and the silver anniversary of Father Ahman's ordination.

During the 1920s and 1930s, the parish continued to make improvements on its buildings and programs. In 1923, fourteen new stained-glass windows were installed in the nave of the church, and in 1933, a new St. Aloysius School was constructed on Eighth Street directly behind the church. Father Ahman died in 1949. Ahman's death also marked a turning point in the parish history. The years following World War II slowly saw the old families move from the neighborhood for the suburbs. The neighborhood surrounding the church and school was becoming less German and Catholic and more Appalachian and Pentecostal. As a result, membership declined.

In 1952, the Sisters of Divine Providence replaced the Sisters of St. Francis in the parish school. The sisters did their best to reach out to the community and stabilize the school. The tide, however, had turned. In 1979,

St. Aloysius School closed with an enrollment of ninety-eight students, and the building was converted to senior housing. Despite this loss, the parish moved on. In 1976–77, the grotto was completely restored by Italian artists Rino Mumphrey and Bert Moriconi.

By the evening of the disastrous fire in 1985, St. Aloysius Parish had been diminished to less than two hundred households; many of them were made up of widows and widowers. The light of day on May 17, 1985, revealed only a shell of the once magnificent church. The tower and cupola had crashed across Seventh Street, and the floor of the nave had collapsed into the grotto. Parishioners and historic preservation experts made a case to try to save what remained of the building, but these efforts were deemed inadvisable by local officials and the Covington Fire Department. Plans were also put forth to replace the building with a small chapel to serve the neighborhood. In the end, the decision was made to remove what remained of the building. It is now the site of a parking lot. The parish rectory and school, however, continue to stand and remind us of the glory days of St. A's.[27]

St. Patrick Church

The Irish Catholic population of Covington had found a home at St. Mary's Parish, later the Cathedral, since the 1830s. As the city grew to the west, a significant number of Irish immigrants and their children began settling in the area north of Sixth Street. In the years following the Civil War, many of the residents petitioned Covington's Bishop George A. Carrell for permission to establish a parish in their neighborhood. They pointed out that the Cathedral Parish was overcrowded and located a significant distance from where they lived. A lot was purchased on Philadelphia Street at Elm Street for a new congregation. However, before work could begin, Bishop Carrell died in 1868.

In 1870, Father Augustus Maria Toebbe was named the second bishop of Covington. Bishop Toebbe moved quickly, establishing St. Patrick Parish, and gave permission to begin construction of a church, naming Father James Smith as the founding pastor. Smith was an immigrant from Ireland himself and a gifted fundraiser. The parishioners commissioned Louis A. Picket to design a Gothic Revival church on the Philadelphia Street lot. The cornerstone for the new church was set in place on August 28, 1870, and

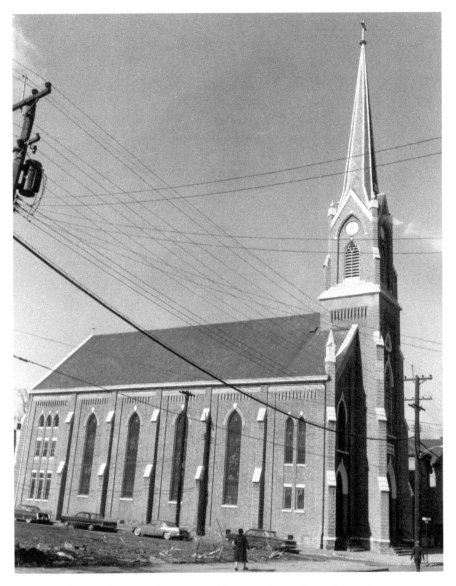

St. Patrick Church, Covington's west side Irish parish. *Kenton County Public Library*.

the building dedicated on August 22, 1872. At that time, the congregation consisted of 124 families. The exterior of the church featured a central bell tower finished with a tall, slender spire. The interior included a Gothic wooden high altar and two side altars. These fixtures were painted to mimic white marble. Above the tabernacle was a life-sized statue of St. Patrick.

The 1870s witnessed many improvements at St. Patrick. In 1875, a two-story addition was constructed on the back of the church to serve as a rectory for Father Smith. One year later, a school opened under the direction of lay teachers. This early school never achieved stability and was closed in 1886. In 1891, the Sisters of Charity of Nazareth, Kentucky, opened a new St. Patrick School with an initial enrollment of 234 pupils. Under the sisters' direction, the school flourished in a frame structure that was built just to the north of the church.

New stained-glass windows were installed in the church in 1897. The windows depicted scenes from the Bible and saints popular in the parish. Also at this time, the church was frescoed, and new stations of the cross were installed. By this time, the parish boasted a membership of over three hundred families and a growing school.

The impetus for a new modern school occurred with the donation of $2,000 from local distiller Nicholas Walsh. Using this seed money, Father Smith began a building fund, but he did not see the new school brought to completion. Father Smith died on February 28, 1908, and was laid to rest in a crypt in the floor of St. Patrick Church. The new pastor, Father James Cusack, was named the second pastor of the parish. However, he died in 1913.

It was left to St. Patrick's third pastor, Father Thomas J. McCaffrey, another native of Ireland, to bring the new school to completion in November 1913. The building contained six classrooms, a gymnasium and an auditorium. Father McCaffrey also oversaw the complete restoration of the church building. In 1917, the exterior brickwork was covered with cut stone that gave the church a very handsome appearance. In 1921, new pews were installed, and the church was re-frescoed by local artist Nino Passalaqua. Artist Charles Svendson painted two large murals in the apse, one on either side of the high altar. The cost of the interior renovations reached $17,000. In 1922, the church was ready for its golden jubilee, which was celebrated with great solemnity. At that time, the parish consisted of 450 member families. In 1928, a convent was built on Fourth Street for the sisters teaching in the parish school.

Several events brought about significant change at St. Patrick. The 1937 flood did considerable damage to all the parish property and resulted in costly repairs. Muddy river water inundated the church, school, rectory and convent. The property was restored, but parishioners began moving from the neighborhood to higher ground. In the years following World War II, this trend only continued. As the Irish Catholics moved out, many

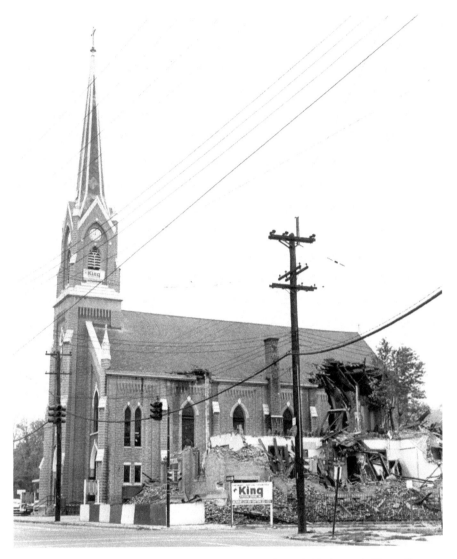

The demolition of St. Patrick School (*foreground*) and Church (*background*). *Kenton County Public Library.*

of their homes were purchased or rented by Appalachians who moved to Covington for a better life and more opportunities. The parish reached out to these newcomers, primarily through the parish school. As early as 1956, the assistant pastor, Father Joseph Dunn, began making plans for a social service center in the neighborhood, but he never received diocesan permission to carry out the project. Diocesan finances were

already spread thin with the expansion of churches and schools in the growing suburbs.

Perhaps the biggest blow to the parish was the death of Monsignor McCaffrey in 1957. He had led the parish for nearly forty-five years and was a constant fixture of stability in the neighborhood. When he died, the parish experienced serious decline. The construction of the Fifth Street Interstate 75 exit ramp and the nearby Internal Revenue Service Center resulted in many homes being torn down. The neighborhood quickly transformed from residential to commercial. In 1967, membership had declined to 150 families, and the decision was made to close the parish and school. Parishioners and students at St. Patrick were encouraged to join nearby St. Aloysius Parish.

The entire St. Patrick Parish plant was demolished to make way for a hotel, gas station and restaurant. Little of the artwork survived. One exception was the statue of St. Patrick that filled a niche in the main altar. The statue was moved to the St. Aloysius Church when St. Patrick Parish closed. In remained there until St. Aloysius Church was destroyed by fire in 1985. At that time, the statue was moved to Mother of God Church on Sixth Street in Covington. The statue, however, always seemed out of place in this staunchly German parish. The statue was again moved to the Cathedral Basilica of the Assumption. Finally, the image of good St. Patrick was moved to St. Patrick Parish in nearby suburban Taylor Mill, where he remains today.[28]

ST. JOSEPH CHURCH AND ST. WALBURG MONASTERY AND ACADEMY

German Catholics poured into Covington in the 1840s and 1850s. As a result, Helentown on the eastside became a German Catholic stronghold. Father Ferdinand Kuhr, longtime pastor of Mother of God Parish on Sixth Street, began organizing these Catholics into a parish. In 1853, the Diocese of Covington was established, and the Reverend George A. Carrell, SJ, was named the first bishop. Bishop Carrell encouraged Father Kuhr's efforts, and a piece of property was purchased at the northwest corner of Twelfth and Greenup Streets.

In the summer of 1854, work on the foundation of St. Joseph Church was begun. Financial difficulties would not permit for the completion of the upper church. Instead, the congregation built a small combination church and school building, which was dedicated in 1855. The parish was

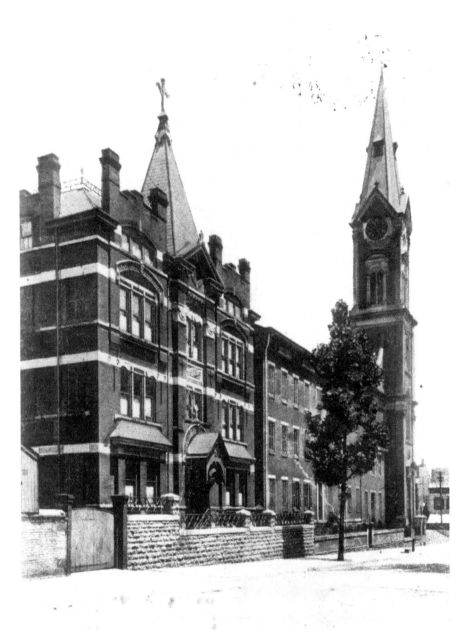

From left to right: St. Walburg Academy (later Villa Madonna College), St. Walburg Monastery, St. Joseph Girl's School and St. Joseph Church before the steeple was destroyed by the 1915 tornado. *Kenton County Public Library.*

cared for by a number of diocesan priests in the early days and the school by lay teachers.

Bishop Carrell lacked a sufficient number of priests to care for the growing number of Catholics in Northern Kentucky. In 1858, he requested the Benedictine priests of Latrobe, Pennsylvania, staff St. Joseph Parish in Covington. The Benedictines agreed and sent Father Oswald Mossmueller and Father Romanus Hell (later known as Hill) to St. Joseph. The two priests not only cared for the parish but also conducted missionary work across Northern Kentucky, laying the groundwork for many new future parishes and schools. Under the direction of these two missionary Benedictines, the original 1854 St. Joseph Church was brought to completion. The Romanesque Revival church was designed by Louis A. Picket and dedicated by Bishop Carrell in August 1859 at the cost of $18,000. The building measured 136 feet in length and 66.8 feet in width.

The Benedictines also established an Institute of Catholic Art at St. Joseph Parish in 1862. The institute was staffed by a number of Benedictine brothers, including renowned artist Cosmos Wolf, OSB. Laymen were also part of the artist corps. These artists included Johan Schmitt and Frank Duveneck. The institute produced altars, organ cases, pulpits, stations of the cross, statuary, altar reredos and other furnishings for churches throughout the country. Among the most spectacular pieces they produced were the high and side altars at St. Joseph in Covington.

In 1859, the Benedictine sisters agreed to staff St. Joseph School for Girls in Covington. The first group of nuns to arrive in Covington were Sisters M. Joseph Buerkle, Mary Anselma Schoenhofer and Ruperta Albert. Sisters Salesia Haus and M. Alexia Lechner soon followed, with Sister M. Alexia as superior. Upon their arrival, the sisters took up residence in a small cottage. In 1860, a new two-story brick convent was ready for occupancy just west of St. Joseph Church on Twelfth Street. The convent was placed under the patronage of Saint Walburg, as was the academy established by the sisters in 1863. The growth of the community and the academy resulted in additions to the convent in 1867 and 1877. The first Covington woman to enter the order in Covington was Helen Saelinger, who became a longtime prioress of the community. In 1890, a separate St. Walburg Academy was built just west of the convent.

In 1870, a new boys' school was constructed on Twelfth Street between Greenup and Garrard Streets. The boys were taught by laymen until 1885, when the Brothers of Mary of Dayton, Ohio, came to Covington. Not only did the brothers teach in the boys' elementary school, but they also founded

St. Joseph Commercial High School for boys, which offered a two-year high school program. The brothers eventually established Covington Catholic High School at Mother of God Parish in 1925 and closed St. Joseph Commercial School.

St. Joseph Parish and schools prospered for many years. In the early 1900s, the sanctuary was tiled, new stations of the cross were set in place and a new marble communion rail installed. The church was officially consecrated on July 16, 1905. In 1910, the firm of Morgan and Sons of New York City supplied ten new stained-glass windows for the church. Those on the gospel side depicted scenes from the life of the Holy Family and those on the epistle side scenes from the life of Saint Benedict.

In 1915, a massive tornado swept through the river cities of Northern Kentucky. Many churches, including St. Joseph, were damaged. The bell tower and steeple at St. Joseph collapsed across Twelfth Street. The architectural firm of Samuel Hannaford and Sons was hired to repair the damages. The bell tower was redesigned, and the original spire was replaced by a graceful cupola. At that time, the congregation consisted of 420 families with 378 children in the parish schools.

In the years following World War I, the parish purchased property at the northwest corner of Twelfth and Scott Streets for the site of a new school. The architectural firm of Kunz and Beck designed the beautiful new school, which was officially blessed on July 29, 1928. It was designed to house both the boys and girls of the parish and was staffed by the Benedictine Sisters. From this point forward, the Brothers of Mary focused on their high school work at Covington Catholic. The parishioners celebrated their diamond jubilee in 1934. At that time, membership stood at two thousand.

Under the direction of Bishop Francis W. Howard, the Benedictine Sisters Villa Madonna College in Crescent Springs was made a diocesan institution in 1929 and moved to the building occupied by St. Walburg Academy on Twelfth Street. As the college grew, the sisters were faced with what to do with the academy, which was being squeezed for space. Reluctantly, the sisters agreed to close the academy in 1931 and turn the entire building over to the college.

The neighborhood around St. Joseph Parish began changing in the 1930s. The population was less German and Catholic and more African American and Protestant. In the 1960s, the Benedictine priests at St. Joseph approached Bishop Richard Ackerman to discuss the future of the parish. One solution was to turn over the parish church and school to the nearby African American Parish of Our Savior which needed more space. Both the Benedictines and Bishop Ackerman, however, did not believe the small

congregation could maintain such a large complex of buildings. In the meantime, St. Joseph School and the Cathedral Parish School were merged under the name Bishop Howard Elementary School at the St. Joseph site.

In 1968, Villa Madonna College left the old St. Walburg Academy building for a new campus in suburban Crestview Hills. On July 10, 1968, the last mass was celebrated in the St. Walburg Convent, and the convent building and academy/college building were demolished. Bishop Ackerman celebrated the last mass in the venerable St. Joseph Church on July 5, 1970. At that time, the congregation had dwindled to less than 150 families. St. Joseph Church was demolished that fall. The stained-glass windows, beautiful hand-carved altars and two large murals painted by renowned artist and St. Joseph parishioner Frank Duveneck were not saved. The only building to survive was St. Joseph/Bishop Howard School. It, too, closed and was sold to the Covington Independent School District.[29]

MOTHER OF GOD SCHOOL

When Mother of God Parish was established in 1841, the parishioners made plans to open a parish school where their children could learn their faith in the German language. Rented quarters were found to house the fledgling school, which was taught by a layman. When the first Mother of God Church was built on Sixth Street, a two-room sacristy was used for school purposes.

The school grew along with the parish, and a one-story brick building was constructed directly behind the church in 1847. In 1855, a second floor was added to this building. A three-story brick schoolhouse was constructed across Sixth Street from the church in 1862. This building contained six classrooms. Two additional classrooms were added to the building in 1887. In 1873, the Sisters of St. Benedict of Covington agreed to teach at Mother of God School. They remained for one year. In the meantime, the Sisters of Notre Dame arrived in Covington in 1874 from Germany. The Sisters of Notre Dame were fleeing the anti-Catholic laws of the Kulturkampf in their native land. They established a convent and academy on Fifth Street behind Mother of God School and took over teaching in the school in 1874.

By 1900, Mother of God parishioners were setting their sights on building a magnificent new school that would rival any in Northern

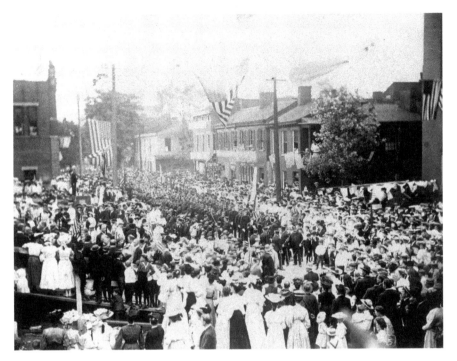

Mother of God School cornerstone laying with grand parade looking east on Sixth Street. *Kenton County Public Library.*

Kentucky. The parish commissioned the well-respected firm of Samuel Hannaford and Sons to design the new school, which was dedicated with impressive ceremonies on September 9, 1906. The Neoclassical building stood on Sixth Street directly across the street from the church. The three-story stone and brick building included a full basement and ten classrooms. Other features included a faculty room and an auditorium complete with velvet theater seating and an orchestra pit. The auditorium seated nine hundred and was used extensively by the school, parish choral society and area Catholic academies and theater groups.

The basement of the new school was used by the Catholic Athletic Club (CAC) as an alternative to the YMCA. The space included a gymnasium, shower rooms, a billiard room, a kitchen and society club rooms. The Catholic Athletic Club was open to all the men of the Catholic parishes in the city.

Mother of God School was the pride of the Catholic school system in the Diocese of Covington and was a symbol of the influence of the church in

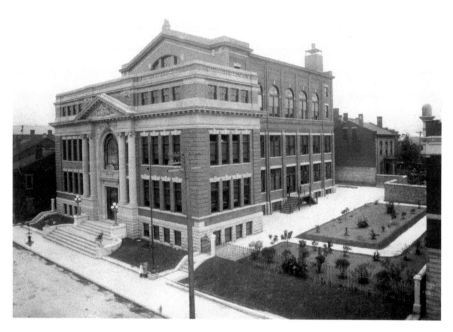

Mother of God School on West Sixth Street was also home to Covington Catholic High School and Good Counsel School. *Kenton County Public Library.*

Northern Kentucky. The school prospered in its new home. As the Catholic school system in Northern Kentucky expanded, Mother of God School was put to additional service. Covington Catholic High School for young men used a portion of the building from 1925 until the new campus was completed in Park Hills in 1955. The growth of Villa Madonna College in Covington required the need for additional classrooms. From 1957 until 1967, the college used classrooms in Mother of God School.

Mother of God Elementary School remained in the building until it was closed in 1962. By that time, enrollment had decreased to one hundred pupils. The flight to the suburbs had taken its toll on the parish and school. From 1962 until 1971, Good Counsel School for special needs children occupied the building.

In 1971, Father William Mertes was appointed pastor of Mother of God Parish. He inherited a beautiful historic church that needed significant repairs and a rapidly deteriorating school. Mertes and the parishioners met on numerous occasions to plan for the future of the parish. It was determined that the members could not save both the church and school. As a result,

the difficult decision was made to demolish the school. The old Mother of God School, which had been such a center of the Catholic community in Northern Kentucky, was torn down in 1974.[30]

IMMACULATE CONCEPTION CHURCH

The first parish in the city of Newport was Corpus Christi, and it served a predominantly German congregation. However, there were a sizeable number of English-speaking Irish Catholics in the parish. For a number of years, these Irish Catholics made do with a separate mass, with the sermon and singing in English. In 1855, with the permission of Bishop George Carrell, SJ, they decided to purchase property on Madison Street (now Fifth Street) for a church of their own. The cornerstone for the new Immaculate Conception Church was set in place on December 23, 1855, and the building was dedicated on December 8 of the following year.

The first pastor, Father John Force, was appointed to Immaculate Conception in August 1856. He was replaced less than a year later with the arrival of Father Patrick Guilfoyle in February 1857. Under Guilfoyle, the parish expanded, with the construction of a school in 1857—later, a second and then a third story were added to the building. The girls of the parish were taught by the Sisters of Charity of Nazareth and the boys by lay teachers.

In 1869, Father Guilfoyle and the parishioners began plans to construct a new, worthier church for the growing congregation. The firm Picket and Sons designed the building. The cornerstone of the church was laid on October 3, 1869, and the building, minus the façade, was dedicated in 1873. The façade could not be completed at that time due to severe financial conditions. The nation was going through a deep recession, and Father Guilfoyle had made massive real estate investments in Newport that collapsed. Guilfoyle's intentions of providing the working-class members of his congregation the opportunity to purchase their own homes was laudable; however, using parish resources to do so proved disastrous. Fortunately, the Walsh, Daly and O'Shaughnessy families were able to donate sufficient funds to keep the new building from falling into the hands of creditors.

In 1878, Father James McNerney was named pastor of Immaculate Conception. His primary goal was to relieve the debt on the parish property. Once this was accomplished, improvements could be made to the church.

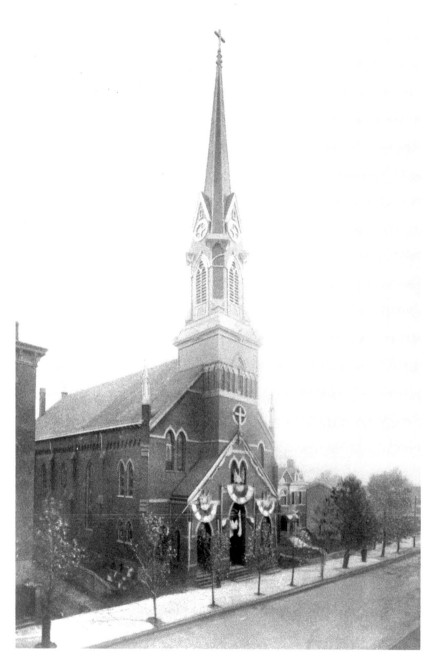

Immaculate Conception Church with completed façade. The parish was home to Newport's Irish Catholics. *Kenton County Public Library*.

The interior was frescoed for the first time, and stained-glass windows were installed. Finally, in 1886, the façade was completed. The beautiful Gothic Revival church stood at the corner of Fifth Street and Central Avenue and was an ornament to the city.

The school also received significant attention during Father McNerney's pastorate. The Sisters of Charity became the teachers of all the boys and girls in the parish. In 1892, a new three-story brick school was constructed. The school was declared a free school, meaning no tuition of any kind was charged for attendance. McNerney celebrated his golden jubilee of ordination on July 2, 1915, at Immaculate Conception Church. The celebratory mood soon turned to mourning when he died seventeen days later.

The Very Reverend James L. Gorey was appointed pastor of Immaculate Conception in 1915 and remained until his death in 1927. He was followed by a series of short pastorates. The next pastor was Father Frances Kehoe, a son of the parish. He remained until his death in 1928. The Very Reverend Joseph A. Flynn was appointed pastor in 1929 and remained until 1932.

The Reverend Gerhard H. Geisen arrived at the parish in 1933. During his tenure, the parish suffered due to the Great Depression and the 1937 flood. Immaculate Conception Church was inundated with over eleven feet of water. The altar, pulpit and all the floors, pews and statues were destroyed. The parish rectory and school also suffered severe damage. The flood made the neighborhood surrounding the church and school less desirable, and many parishioners moved. Newport's west end was becoming increasingly African American and Appalachian. These new groups had little experience with the Catholic Church and, in many cases, were hostile to it. Despite these difficulties, the parish began outreach efforts to the community. The result was a large number of converts to Catholicism in the parish. In 1946 alone, the parish recorded forty-six converts. A number of these converts were African American, and by 1955, seventeen African American students were enrolled in the school. At this time, Immaculate Conception was one of only a handful of schools, public or private, with an integrated student body in the area.

In 1957, Newport became the first city in Kentucky to receive a federal urban renewal grant. The $2 million grant was earmarked for "slum clearance." As a result, several hundred homes fell to the wrecking ball in the west end. By 1964, twenty blocks of Newport had been cleared for renewal. In the west end, much of this land was set aside for multifamily public housing.

Immaculate Conception could not survive the changes occurring in Newport. The parish school was closed in 1968 and the parish itself on July 31, 1969. The church, school and rectory were all demolished, leaving a gaping hole in the once thriving neighborhood.[31]

TEMPLE ISRAEL

Covington once had a thriving Jewish community and synagogue. By the early 1900s, about thirty-five Jewish families, mostly of Russian and Polish descent, were living in the city. Many owned businesses and were active in civic affairs. In 1911, this community of Orthodox Jews requested that Rabbi Samuel Levinson of the United Hebrew Congregation in neighboring Newport, Kentucky, offer services in Covington. The first formal services were held in the Kentucky Post Building on Madison Avenue.

The Covington congregation immediately began a building fund, and by 1912, the community was ready to construct a building. Property was purchased on Seventh Street between Scott and Greenup Streets (the site of the current Covington Post Office). In 1913, a building committee was established with the following officers: Meyer Berman (president), Oscar Levine (vice president), L. Gorshuny, Max Stampil, I. Simon, M. Chase, H. Lipschitz, A. Gross, M. Meisel and J. Ginsberg (officers).

The new, two-story Classical Revival–style synagogue—designed by architect George Schofield—was ready for occupancy in 1915. The façade featured columns, and the hipped roof was topped by a cupola. The first floor contained a kitchen, classrooms and living quarters for a caretaker. The main floor housed the worship space. Since the congregation was Orthodox, the seating area was divided by gender. The new synagogue was named Temple Israel.

Rabbi Levinson, a Lithuanian immigrant, cared for both the Covington and Newport congregations from 1911 until 1923. He focused entirely on Temple Israel from 1923 until his retirement in 1929. His successor was Rabbi Jacob Jacobs.

Temple Israel remained at its Seventh Street location for several decades. In 1937, the federal government condemned the building and purchased the property. The building was demolished in 1938 to make way for Covington's new post office and federal courthouse. The Temple Israel congregation purchased a lot at 1040 Scott Boulevard as a site for a new synagogue,

Covington's second Temple Israel at 1040 Scott Boulevard when it was being used as a church. Notice the Stars of David over the front windows. *Kenton County Public Library.*

which was dedicated on March 19, 1939. The simple two-story building cost $20,000 to construct. The exterior was severely plain and featured two small stone stars of David and a cornerstone written in Hebrew.

The congregation was declining at the time the new Temple Israel was completed. Many of the Jewish residents of Covington were moving to Cincinnati, which provided many more opportunities for Jewish families. Despite moving their residences, many of the families continued to maintain their flourishing businesses in Covington. This migration to the Queen City continued throughout the 1940s and 1950s. Declining membership resulted in the lack of worship services on many Sabbaths due to a lack of quorum. (In Orthodox synagogues, at least ten male members must be present for worship.) By the early 1960s, only the High Holiday services were being conducted. The congregation ceased operation by the mid-1960s. The building was sold to the Church of God in 1973 for $9,400. The building was eventually purchased by the Carnegie Center for Visual and Performing Arts and demolished in 2006 to make way for a parking lot.[32]

SCHOOLS AND CIVIC BUILDINGS

COVINGTON CITY HALL

Many people remember the old Covington City Building that sat at Third and Court Streets at the site of today's Roebling Suspension Bridge on ramps. Sitting just a couple blocks from the Ohio River, it was a magnificent building and also housed the offices of the Kenton County government. The city and county governments were previously housed in a structure that outgrew its usefulness. Covington and Kenton County were growing and so was the size of the government. The 1843 building was razed in 1899 to make room for a new city hall. During construction, the city made its temporary offices at the Hermes Building, now Molly Malone's. Dedicated in 1902, the new Covington–Kenton County Building was three stories and had a gable roof lined on each side with a higher tower in the middle. The gabled structure was designed by the architectural firm of Dittoe and Wisenall, which designed many beautiful and historic buildings in Covington, including First Christian Church, the Kentucky Post Building and an addition to Citizens National Bank. The new City Building was composed of brick with a stone foundation and had an archway of stone at the top of entrance steps on Court. It took up the entire block from Court to Greenup and was located on the north side of Third Street. Perhaps the most impressive aspect of the new government building was its appearance as people came across the

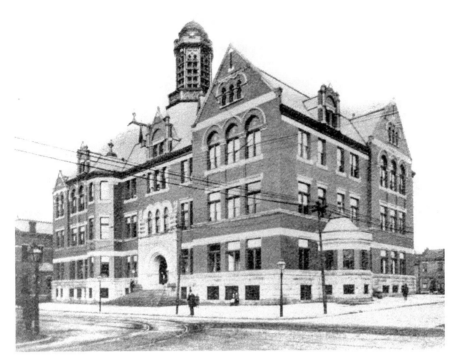

Covington City Hall and Courthouse, Third and Court Streets, Covington, Kentucky.
Kenton County Public Library.

Suspension Bridge into Covington and saw its beautiful and impressive design. It was the dominant structure upon entering Covington from the bridge.[33] The building was razed in 1970.

The City Building saw almost seventy years of history and politics of Covington. It was an interesting time, spanning from near the turn of the century to the opening of Riverfront Stadium just across the river and on the other side of the Suspension Bridge. A brochure in 1903 offered tax breaks to companies moving to the city and touted that "Covington also offered cheap coal, good transportation and the best water in America."[34] According to writer Jim Reis, "[B]usinessmen touted Covington as an ideal spot for tobacco factories and warehouses with a base of 7000 union laborers and an excellent streetcar system." Despite the growth leading to the need for the new city hall, more was to come. Around the time of construction, Covington grew outside its borders. It annexed Peaselburg in 1906 and Latonia and West Covington in 1909. It failed in attempts to annex Ludlow.[35] The building served Covington well until its demolition in 1970.

Covington High School

Although Covington has had a public school of some type since 1825, the very first public high school was established in 1853. The district organized formally in 1841 when the city council created a board of five citizens to oversee public schools in the city. The next year, the new board started constructing schools.[36] Between 1842 and 1852, the first four district schools were built, and by 1925, eleven district schools had been constructed for white elementary school children. In 1872, the beautiful Covington High School building was opened. It was located at Russell and Twelfth Streets and was a twelve-classroom, three-story brick building. It is best described as Victorian Gothic.

The cornerstone was laid on October 25, 1872. By 1880, there were five faculty members and 172 students. According to the bicentennial book *Covington, Kentucky: 1815–2015*, "The Covington High School was described as having a comprehensive program that offered three graduation courses—a commercial course, a general academic course, and a manual-training course." Around this time, Covington's second high school, one for black students, opened. It was named for William Grant, who donated property on Seventh. There were significant differences between the course offerings of the Covington High School and the William Grant High School. Again, according to the Covington bicentennial book, "The William Grant High School was referred to as a standard high school, and the graduates were listed as having received a general degree."

It did not take long for Covington High School to become overcrowded. By 1896, it was beyond capacity. This lasted for over twenty years. In 1915, a bond issue was placed by the school board for funding a new high school building. It failed, and the problem grew worse. In January 1916, another bond issue for $165,000 was placed

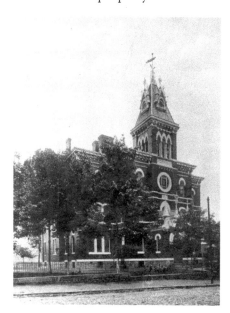

Covington High School. *Kenton County Public Library.*

on the ballot in part because the high school building capacity was 400, with enrollment at 471. By 186 votes, this second bond issue passed.

The cornerstone of a new building was laid on November 27, 1916. Opened in 1919, Holmes High School was located on the Holmesdale property. The school board paid $50,000 for the property from the Holmes estate, which included the Holmes mansion. Daniel Henry Holmes was a wealthy merchant and department store owner from New Orleans. The mansion was better known as the Holmes Castle and stood until 1936, when an administrative building was constructed on the site.

As a result of the opening of Holmes High School, the old building at Russell and Twelfth Streets was left vacant. The school board decided to remodel the old high school building and reopened it in 1919 as a junior high school. They named it John G. Carlisle Junior High School. It served in this capacity until 1937, when a new John G. Carlisle Elementary and Junior High School was constructed.[37] The old high school building was then demolished.

HOLMES CASTLE

Daniel Henry Holmes Sr.'s parents died when he was two years old, and he was raised in the Columbia section of Cincinnati by his brother Sam. As a young adult, Holmes went to New York City and worked at the Lord and Taylor Department Store, and when the company opened a new store in New Orleans, Holmes became its manager. Eventually, Holmes bought the store in New Orleans and renamed it the Daniel Holmes Store. He became a very rich man. According to the *Encyclopedia of Northern Kentucky*, Holmes "purchased all of his merchandise in Europe, where he was known as the 'King of New Orleans'. By the 1960's, the Holmes Department Store Chain operated 18 department stores in three states. It was among the largest independent department store chains in the nation.

"Not wanting to keep his family in the hot South in the summer, he built a summer home in Covington, on what is now the Holmes campus. His original estate was called 'Holmesdale,' and more or less was bordered by Madison, 25th Street, the Licking River, and Lavassor Avenue. He also had homes in New York City, New Orleans, and Tours, France."[38] It was during or just after the Civil War when Holmes moved his family to Covington. Following the war, he purchased for $200,000 a large Victorian Gothic house

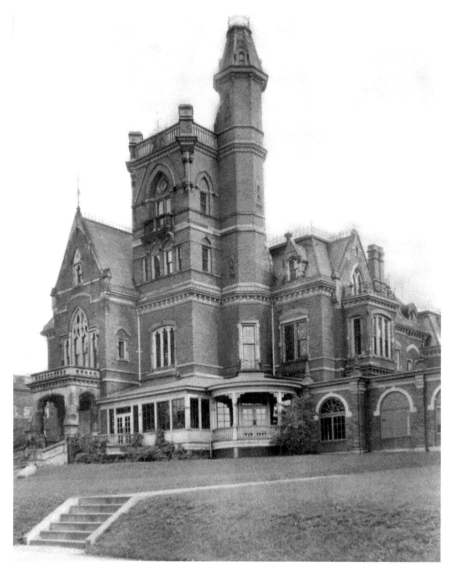

Holmes Castle, home of Daniel Henry Holmes. *Kenton County Public Library.*

and named it Holmesdale. The mansion is better known as Holmes Castle. Upon his purchase of the castle, Holmes hired a Boston firm to create a landscape plan with a pond, pasture and hundreds of trees. A groundskeeper kept cows and sold milk from the property to neighbors.[39] Holmes Castle, according to an article published by the Kenton County Library, is likely the most well-known example of lost architecture in Covington "and was

designed in the Gothic Revival style, which can be identified by its pointed arch windows and church-like details." It had sprawling grounds and a lavishly appointed interior. The thirty-two-room estate house was designed after a castle in Siena, Italy.

Holmes died on July 3, 1898, at his apartment in New York City. His body was returned to the Castle for services and was later buried in a family crypt in a suburb of New Orleans. He left the mansion to his son Daniel Jr. The family sold the mansion to the Covington Board of Education for $50,000 in 1919, and it was used as a cafeteria and classrooms for sixteen years but was demolished in 1936. According to the Holmes High School website, "In November of 1936, the senior class was given a tour of the Castle. An auction was held, and anything that could be removed was put up for sale. Any furnishings that remained were taken down to the football field and burned. Over the Thanksgiving holidays, the wreckers moved in, and the Castle was razed."

COVINGTON POST OFFICE/FEDERAL BUILDING

Described as an "architectural jewel" of the city of Covington, the U.S. Post Office and Federal Building was a large Victorian Gothic structure. It stood at the southeast corner of Third and Scott Streets. Even before the Civil War, a federal building/post office was considered for the city of Covington. In the early 1870s, the U.S. government allocated $250,000 for the project. The project started when the Treasury Department purchased a 167-foot by 150-foot lot for $30,660.55—the Third and Scott Street site. According to the Kenton County Public Library webpage and research, "The building was designed by William Appleton Potter, Supervising Architect of the United States Treasury Department. The 3-story structure was built of native limestone on 3' thick foundations. The exterior was decorated with intricate stone carvings and an ornate mansard roof. The interior included woodwork of ash, fruitwood and oak; marble columns and detailed molded plaster friezes in the courtrooms. The cornerstone of the building was set in place on July 4, 1876, the centennial of the Declaration of Independence. Total cost of the structure amounted to $264,231.01"[40] Potter was known for his design of many structures at Princeton University and municipal buildings, and he served as supervising architect of the U.S. Treasury. The

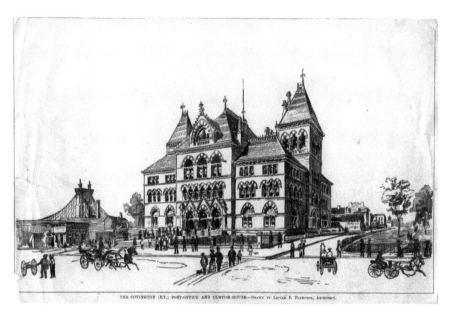

THE COVINGTON (KY.) POST-OFFICE AND CUSTOM-HOUSE—DRAWN BY LUCIAN F. PLYMPTON, ARCHITECT.

Covington Federal Building, "an architectural jewel." *Kenton County Public Library*.

Richardsonian Romanesque style is identified by "heavy stone masonry, lots of arches, and decorative belt course banding between floors."[41]

During its time of service, the federal building housed the Covington Post Office and the federal courts. In 1946, the building was abandoned by the federal government when a new structure was constructed on Scott Street and Seventh Avenue. The old federal building was sold to Kenton County for $15,000 and eventually became home to the Kenton County Vocational School. The school left the building on June 5, 1962, to move into a new facility. The county used the old federal building for storage until 1968, when it was demolished. On its site, Kenton County built a new government building for its operations. The high-rise building sits at the foot of the Roebling Suspension Bridge and houses the administrative office of the county. Until a new corrections facility was built, the county jail was located on the upper floors.

In August 1999, a new federal courthouse opened on Fifth Street. It was constructed for $22 million and came in $1 million under budget. The Scott Street federal building (the second federal building) was given entirely to the postal service, which still operates out of the facility.

SPEERS MEMORIAL HOSPITAL

Elizabeth L. Speers was a wealthy resident of Dayton, Kentucky. She and her husband, Charles, settled in Dayton in 1883. Unfortunately, Charles died that same year. When she died in 1894, Elizabeth gave $100,000 to build a hospital in Dayton named after her late husband. The family money was made by Charles selling cotton during the Civil War. In accordance with the will, a circuit court judge appointed trustees for the new hospital, and they met for the first time on July 6, 1895. Construction of the hospital was begun in October 1895, and in 1897, the facility admitted its first patient. In the beginning, the hospital had thirty private rooms and four wards. In 1911, an east wing was built, adding another ward and seven more private rooms.[42] The additional ward was for children.

Speers Hospital was built at a large block of Main and Boone Streets and Fourth and Fifth Avenues. The total cost was $75,000, and Elizabeth Speers's donation provided for construction and equipment purchases. It did not provide for operating costs, which included thirty-one doctors, many of them quite prominent for the area.[43] A nurse training program was started in 1901, and three years later, the first class of seven women graduated. The ceremony was held at the Dayton High School auditorium. Other major developments in Speers Hospital's history include a deal with the Chesapeake and Ohio Railroad in 1912 to care for employees and the construction in 1937 of a residence for student nurses. Speers became known as "a railroad hospital." By the time of the great flood of 1937, the hospital had one hundred beds, five wards and thirty-eight patient rooms.

However, in 1937, the flood caused devastation not only to the hospital but to the entire region as well. Patients were removed to the Dayton High School and other facilities in Bellevue and Newport. Floodwaters made it into the first floor, ruining equipment and resulting in major damage. The Campbell County Chamber of Commerce led a fundraising campaign to help the hospital. According to the *Encyclopedia of Northern Kentucky*, "In 1938 a number of prominent physicians lectured at the hospital. The speakers included the world-renowned brain surgeon Dr. Frank Mayfield and the developer of the first live polio vaccine Dr. Albert Sabin." Speers Hospital ran into problems in the years following the flood. The new equipment aged, and the facility was in need of modernization. The funds were not available. In many ways, public support for the hospital began to wane, and many questioned its existence. By the late 1940s, doctors grew even more concerned about the Speers facility and discussed the need for a new

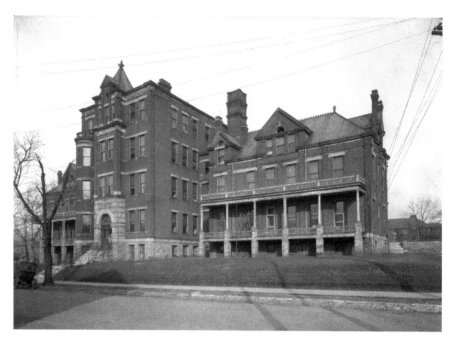

Speers Memorial Hospital, Dayton, Kentucky. *Kenton County Public Library.*

hospital. Seven doctors led efforts for a $1 million bond issue for a new hospital. The issue was approved by the voters, and a new modern hospital was constructed in 1954—St. Luke Hospital. It was located in Fort Thomas and today still stands as St. Elizabeth Hospital. Speers actually survived for many more years and ceased operations in 1973 after being purchased by St. Elizabeth Hospital of Covington. Speers Hospital sat vacant for six years and was demolished in 1979. Senior citizen housing was built on the site approximately four years later.

FORT THOMAS MILITARY RESERVATION

The military barracks of Newport were covered heavily by water in the great floods of 1884 and 1887. As a result, it was decided to move the barracks to a new reservation in Fort Thomas that offered higher grounds, fresh water, train transportation for materials and accessibility by streetcar to the urban core of Cincinnati, Newport and Covington. The Kentucky General Assembly ceded that land to the federal government for the military

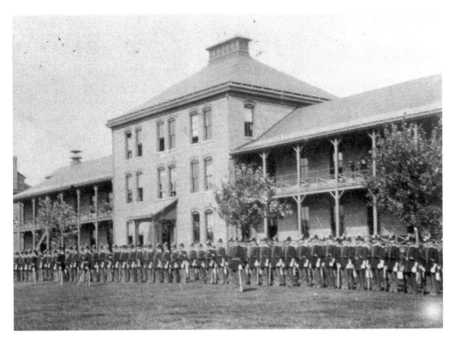

Fort Thomas military barracks. *Kenton County Public Library.*

reservation, which was dedicated on June 29, 1890. Congress appropriated $3.5 million for construction, and it began quickly. First named Fort Crook, the establishment was later renamed by Army Chief of Staff General Phillip Sheridan to honor General George Henry Thomas. Thomas was known as the "Rock of Chickamauga." The Battle of Chickamauga and Thomas's defeat of Confederate general John Bell Hood in 1864 was a decisive battle in the Civil War.

The first buildings at the fort were funded by Congress in 1887. The first commanding officer was Colonel Melville A. Cochran, and the first troops arrived in 1890. These troops, the Sixth Infantry, started what would be a military operation until the 1960s. Over thirty buildings would eventually be built at the fort. The water tower, which became the symbol of the fort and the city, was constructed in 1889–92.[44] It was the sixteenth structure built at the fort and spans 102 feet. Enclosed within its walls was a standpipe with a capacity of 100,000 gallons. It was constructed at a cost of $10,995. In 1891, the mess hall was finished at a cost of $20,407 and today serves as a beautiful community center. One of the most famous Fort Thomas troop assignments started in April 1898 with the outbreak of the Spanish-American War. The

Sixth Regiment joined the rest of the army in Tampa, Florida, and left for Cuba and participated in the Battle of San Juan Hill. During this time, the barracks were used as a temporary hospital, and the army regiments stayed in tents on the property.

During the twentieth century, the fort stayed in use but was more limited. During World War I, the fort was a recruit center, and seventy thousand men passed through. Twenty temporary buildings were constructed. In 1922, the Tenth Infantry arrived and remained at the complex until 1940. The unit was called upon to do community service at various times, especially during the Great Depression.

The fort served as an induction center during World War II. Paul Tibbets was inducted at Fort Thomas as a flying cadet—Tibbets was the pilot who dropped the first atomic bomb in August 1945. According to the Campbell County Historical Society, three thousand men passed through the fort per week. It served in this capacity until the end of the war in 1945. A rehabilitation center was opened in 1944 by the Department of Veterans Affairs. Starting in the 1960s, the Department of Defense began to dispose of the fort, and in 1964, the last soldier went through the induction center. The facility became a nursing home operated by the Department of Veterans Affairs in 1967. In 1972, the land was subdivided and sold. Land was also transferred to the City of Fort Thomas for what is now called Tower Park.

NEWPORT BARRACKS

Fort Washington in Cincinnati was the first military post in the Greater Cincinnati area and was built around 1789. Several things changed in a short time frame. Indians were no longer much of a threat to the region, and the land Fort Washington sat on (Third and Broadway) in downtown Cincinnati had become quite valuable. Across the river was an opportunity with two things going for it. First, the land was a good location, right on the conflux of the Ohio and Licking Rivers. Second, moving the fort to Newport had a big supporter—General James Taylor, one of the richest and most influential individuals in Kentucky. Not only was he the founder of Newport, he was the cousin of two future presidents, Madison and Taylor, as well. It was decided to move the fort and establish the Newport Barracks. In 1803, on approximately four acres, the Newport Barracks was established. The land was bought for one dollar from the Taylor family, but an additional two acres were purchased in 1806 because the original purchase proved to

be too small. This time the acres were bought for forty-seven dollars each, and people questioned why such a high price was paid.[45] In 1848, the City of Newport gave additional land to the government. General Taylor was chosen to oversee construction of the barracks and, according to the federal government, was charged with constructing three buildings: a two-story arsenal, barracks and a circular brick powder magazine.

The first group of soldiers to occupy the barracks as a permanent garrison did so in July 1806. Steve Preston described some early action in an article titled "Our Rich History: When the Army Came to Newport":

> [A]s the United States began its second war with England, the War of 1812, the Newport Barracks became the major supply and mobilization point for the Western Theater. Although war materiel was hard to come by, much of what was available came through Newport on its way to troops fighting in Northern Ohio and near Detroit. Units such as the 4th Regiment, 7th Regiment, 17th Regiment and nearly all Kentucky Militia units passed through Newport. During the Mexican American War, the

Newport Barracks,
OPPOSITE CINCINNATI.
WITH PART OF NEWPORT AND COVINGTON.

Newport Barracks. *Kenton County Public Library.*

Newport Barracks was heavily utilized. Its location on the Ohio River provided rapid deployment for troops heading to the Mississippi River and Louisiana, and thence to Mexico. The Barracks was at its peak as it sent recruits to Louisiana, soon after Mexico broke off diplomatic relations with the United States in 1845.

In 1814, the barracks held approximately four to six hundred prisoners of war, most from General William Henry Harrison's victory at Moravian Town in 1813.

During the Civil War, the Newport Barracks was a Union post. It served as a prisoner-of-war camp and hospital. The downfall of the fort resulted from neglect after the Civil War, and its fate was sealed by the great floods of the 1800s. In fact, it was flooded three straight years: 1882, 1883 and 1884. The Newport Barracks covered in water prompted the federal government to move to Fort Thomas. In 1887, it was recommended that the barracks be abandoned, and General-in-Chief Phillip Sheridan agreed. In 1896, after some debate, the City of Newport accepted the return of the property. Today, the site of the Newport Barracks is the General James Taylor Park, located on the Licking and Ohio Rivers.

BOONE COUNTY COURTHOUSE, 1817

The old courthouse currently standing in Burlington is in reality the third courthouse built on the corner of Washington and Jefferson Streets. Between the years of 1799 and 1801, county functions were conducted in homes until the first courthouse was constructed. The 1801 courthouse was made of logs. It had only served as the official courthouse for around sixteen years when it was replaced with a larger two-story brick building in 1817. In addition to the courthouse, in 1817, several other notable occurrences took place, including the Anderson Ferry carrying its first goods across the Ohio River, the Benjamin Piatt Fowler House being built near Union and the Petersburg Mill incorporating.

The 1817 courthouse was remodeled several times and eventually replaced in 1889 when a new one was built. The 1889 courthouse still stands on the site of the two previous buildings and was renovated in 2017. It was named the Ferguson Community Center in 2018.

The Morgan Academy

Very few people in Northern Kentucky are aware of the Morgan Academy of Burlington. Long lost to history, the academy was a private school, as were most early schools of Northern Kentucky. Originally known as the Boone Academy, it was an important learning institution in Boone County. Established in 1814, it was funded by the sale of seminary lands set aside by the Commonwealth of Kentucky following its entry into the United States. It had various names throughout the years, including Boone Academy (1814–32), Burlington Academy (1833–41) and Morgan Academy (1842–97). According to the *Encyclopedia of Northern Kentucky*, "By 1842 the new name, Morgan Academy, had been cut in stone and etched in gold leaf on the front of the Academy's building."

Allen Morgan, a Boone County resident, died without a will or heirs, and under Kentucky law, estates in this situation had to be donated for educational purposes. The Morgan Academy adopted his name after inheriting his estate. Tuition near the end of its operation was $1.50 per month for primary students, $2.50 for intermediate students, $4.00 for high school. Room and board was an additional $2.50 to $3.50 per week.[46] County leaders who attended Morgan Academy include J.W. Calvert, Dr. Otto Crisler, J.W. and Fountain Riddell and Dr. Elijah Ryle.

In 1835, a Lawrenceburg, Indiana newspaper reported an order of the Morgan Academy Board of Trustees that "teachers are wanted to conduct the male and female departments of the above Institution, as both the teachers now engaged in said school will leave at the end of the present session. No teacher need apply whose moral character is not unexceptional, and who cannot come well-recommended, as it regards qualifications, to teach a respectable Academy. The next session will commence on the first Monday in October ensuing."[47] In 1840, the academy had sixty students and a $5,000 endowment.[48]

Morgan Academy closed in 1897, just ahead of school reform in Kentucky that changed the landscape. According to Margaret Warminski, writing for the website Chronicles of Boone County by the Boone County Public Library,

A series of reforms enacted by the Kentucky legislature beginning in 1908 revolutionized education and raised standards. In the wake of these changes, local school districts began to consolidate into larger entities serving wider geographical areas, and one- and two-room schools were replaced by new

buildings. Throughout the county new buildings were constructed housing grades one through twelve under one roof, with primary and secondary classes on separate floors. High schools also were established in Burlington, Union, Walton and Verona. The next major building campaign took place in the 1930s, as graded schools of conspicuously modern design were built in Florence, in Burlington and on U.S. 42 south of Union.

The Morgan Academy building was located next to the Old Burlington Cemetery and shared a fence with the burial ground. It was a two-story red brick colonial building "well-constructed with two class rooms below and an assembly hall on the second floor. The front entrance opened into a hall from which a stairway led to the second floor where dances and town meetings were held. (In the) back of the hall was a large class room. (In) back of this was another hallway with an outside door at either end and another door opening into another large classroom at the back."[49] Today, the site is an empty lot.

4

RECREATION

Ludlow Lagoon Amusement Park

The Lagoon Amusement Park had its inception with the construction of Highway Avenue and the streetcar system through the city of Ludlow in 1894. The owners of the streetcar company wanted to capitalize on more than just local riders, so they planned for an attraction at the end of the line. A dam was constructed across the Pleasant Run Creek between Ludlow and Bromley, forming a large lake and the perfect location for a summer resort. On January 29, 1894, the park project was announced to the public. The major backers of the project were all associated with the streetcar company: C.B. Simrall, J.J. Shepherd, Samuel Bigstaff, George M. Abbott, T.M. Jenkins and J.J. Weaver.

Initially, the park included a large eighty-five-acre lake dotted with five small islands. The lake was always the major attraction in these days before air conditioning. On the north shore of the lake was a boathouse and bathing beach. These two features were draws from the beginning. A fleet of boats provided park goers with endless entertainment. By opening day, over one hundred boats were available for rent. These included four electric launches that could carry thirty-five passengers at a time. These battery-powered launches were purchased from the World's Columbian Exposition in Chicago (commonly known as the Chicago World's Fair).

The major buildings at the Lagoon when it opened were all designed by Ludlow architect John Boll. The most impressive was the two-story frame

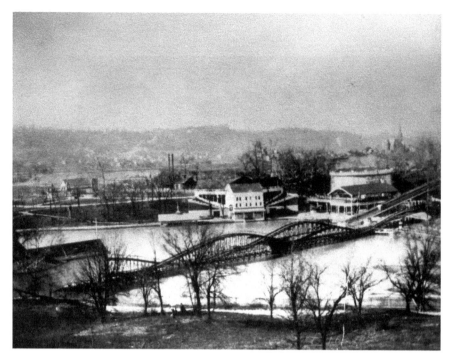

The Ludlow Lagoon Amusement Park from the west. Notice the Scenic Railway in the foreground. Along the lake, *from left to right*: the entrance pavilion and car barn, the boathouse and theater with amphitheater behind and the large dance hall. *Kenton County Public Library.*

clubhouse, which was constructed at a cost of $6,000. The building featured wraparound verandas to catch the summer breezes and operated as a lounge and restaurant. Park officials spared no expense in hiring the best chefs and waitstaff. The park also contained a large dance hall topped by a spectacular rooftop garden and an amphitheater seating 2,000 (later enlarged to seat 3,500). The castle-like entrance building was constructed on Laurel Street between Park Avenue and present-day Lake Street. During the height of the park's popularity, a streetcar left Fountain Square every five minutes—full of revelers heading for the Lagoon.

The Lagoon borrowed a number of new ideas from the Columbian Exposition, including a midway that featured games of chance and food booths. This area of the park also included a carousel, shooting gallery, bumper cars and an Edisonia exhibit, which displayed many of Thomas A. Edison's inventions.

The most popular ride at the Lagoon was the Scenic Railway, or roller coaster. The father of today's modern roller coaster was LaMarcus Adna Thompson. In 1884, Thompson designed one of the first practical roller coasters at Coney Island in New York City. Thompson was hired to design Ludlow's Scenic Railroad. The electric ride began on the banks of the lake, and patrons traveled on an undulating track over the water. At several points, the cars entered tunnels. Cars eventually entered a circular structure and traveled over a corkscrew track. The riders then reemerged into daylight for the return trip to the lakeshore.

The park also had a large Ferris wheel, which was located on one of the islands, and a Shoot-the-Chutes. This ride was a tall tower and platform built on the shoreline. Patrons climbed the tower and entered small flat-bottomed boats that were then released down a ramp into the water below. The Ludlow Shoot-the-Chutes was built in 1896, but it did not last for many seasons due to safety issues.

Electric lighting was added to the park in 1903, replacing many of the original gas fixtures. At this time, many of the park rides and the lake were lit. This added another dimension of innovation to the park, as many area residents did not have electricity in their homes. In 1906, a moving-picture theater was added to the park—one of the first in Northern Kentucky.

In 1909, Lagoon managers came up with a new ride called the Automobile Scenic Railway. The ride was an elevated two-mile track built in a rough figure-eight format. The track ranged in height from one foot to twenty-eight feet. A fleet of Buick touring automobiles were bought in Detroit, and riders drove the cars across the track and at times were above the treetops. The attraction was advertised as the only one of its kind in the world.

Other early attractions at the park were model battleships. These ships were usually part of the evening festivities. Fireworks were shot from them to simulate naval battles. Initially, the battleships played the roles of the famous Civil War–era ships *Monitor* and *Merrimac*. During the Spanish-American War, the ships' maneuvers portrayed Admiral Dewey's victory at Manila Bay.

Lagoon management also capitalized on the Russo-Japanese War of 1904–5. Japan's stunning victory over the navy of Russia sparked a fascination with all things Japanese in the United States. The owners brought in Japanese carpenters to build an authentic tea house in the park, and the building was decorated with photographs from the war, as well as artwork and pottery imported from Japan. Activities included a jujitsu instructor, traditional Japanese board games and music.

Vaudeville troops touring the country often made stops at the park. The Lagoon's theater and amphitheater proved to be quite popular year after year. Bands played each weekend during the season. In the summer of 1908, Alessandro Liberati (1847–1927) and his orchestra performed live to jam-packed audiences at the park for a week. The Lagoon also played host to the Hungarian Royal Orchestra one summer.

One of the most exciting attractions at the park was the Motordrome. Lagoon management completed the construction of an oval wooden track for motorcycle racing in 1913, and it opened on June 21. Surrounding the track was a large grandstand capable of seating a crowd of eight thousand. The audience and the motorcycles were separated from each other by a heavy gauge wire mesh.

On July 30, 1913, the Motordrome was a scene of devastation for nearly five thousand spectators. The Moose Sweepstakes were being held, and the large purse had attracted some of the best motorcycle racers on the circuit. One of these was Odin Johnson, a thirty-four-year-old resident of Salt Lake City, Utah. On the twelfth lap of the race, something went

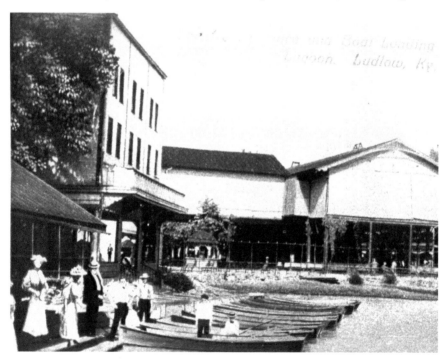

Ludlow Lagoon theater and dance hall. Notice the many boats, which were a large attraction for the park. *Kenton County Public Library.*

terribly wrong. Johnson was driving his motorcycle toward the top of the oval, and he lost control, slamming into the heavy wire mesh that separated the track from the audience. The crash, however, resulted in one of the large arc lights being knocked into the stands. Dozens of onlookers were showered with flaming gasoline. The severely injured were transported to St. Elizabeth Hospital in Covington. Odin Johnson and his wife were taken to St. Elizabeth. The Sisters of the Poor of St. Francis, who operated the hospital, and the crew of doctors and nurses on duty did heroic work under discouraging circumstances. One of the sisters tended to Johnson, who died of a fractured skull.

Newspaper accounts and other sources are not clear on the total number of deaths. It is known that at least ten people died as a result of the Motordrome accident. Lawsuits quickly followed. In the August 1, 1913 edition of the *Kentucky Post*, editors called "To stop the slaughter" at the Motordrome. The editorial continued, "[W]e are not ready to concede as legitimate or sportsmanlike a race in which the competitors are constantly in danger, not only of death and injury to themselves, but of bringing horrible death and injury to scores of innocent spectators." The story of the tragedy made headlines across the United States. An account was even featured in the *New York Times*. Despite the calls to shut down the Motordrome, it reopened on August 16, 1913, to a crowded grandstand.

The Motordrome incident tarnished the reputation of the park. More difficulties were to follow that would eventually result in the closing of the park. The great flood of 1913 crested at 69.9 feet. Floodwaters weakened the dam, nearly destroyed the midway and did considerable damage to a number of the rides. The repairs were both costly and extensive. Two years later, the 1915 tornado sept through the park on July 7. By the time the storm ended, extensive damage had been done to the Scenic Railroad and carousel. The roof of the dance hall was gone, and significant portions of the Automobile Scenic Railroad were swept away. In addition, a 160-foot section of the Motordrome was smashed, leaving only a pile of splinters behind. Damage to the park was estimated at $50,000. Repairs were made quickly, and the park reopened and finished out the 1915 season.

In 1917, the United States entered World War I after a long period of isolationist sentiment. As a result, the government began rationing food for the war effort, including wheat. An unintentional result of this rationing was a greatly reduced supply of beer. Without the sale of beer, the park would be unable to make a profit. In June 1918, park officials announced that the park would not open for the season. Park owners hoped once wartime

prohibition was lifted that they could reopen; however, on January 16, 1919, the Eighteenth Amendment to the Constitution (commonly referred to as the Volstead Act) was ratified and took effect on January 16, 1920. The 1917 season was the last for the Lagoon.

In 1923, the City of Ludlow annexed most of the Lagoon property. This opened the door for the construction of hundreds of new homes in Ludlow's west end. The new subdivisions built on the former Lagoon property included Lagoon Land Addition (the 200 block of Lake Street) and the Lagoon Addition (including Deverill, Ludford and Stokesay Streets, all named after places in Ludlow, England).

Today, only a few reminders are left of the park. The most prominent is the old clubhouse at the corner of Lake and Laurel Streets. The small caretaker's house also remains. The white frame Victorian home sits at the corner of Deverill and Lake Streets and is used as a private residence.[50]

Latonia Racetrack

Latonia Racetrack was one of the nation's finest courses. The track was established in 1882 by the Latonia Agricultural and Stock Association on property at Thirty-Eighth and Winston Avenue south of Covington. The first day of races occurred on June 9, 1883. Between 1883 and 1919, ownership of the track changed hands several times. Finally, in 1919, it was purchased by the Kentucky Jockey Club. The club was an association of racetracks under the leadership of Matt J. Winn, one of the preeminent horse racing proponents in the country and a significant advocate of the Kentucky Derby.

In 1888, the Latonia Derby was run for the first time on May 28. The first Latonia Oaks was held in 1887. These two races proved very popular and, for a number of years, rivaled the Kentucky Derby and Kentucky Oaks in participation and purses earned.

The Latonia course received another boost with the extension of the electric streetcar lines to the area in 1893. This allowed residents from Covington, Newport and Cincinnati to easily travel to the track at reasonable rates. The track's proximity to Cincinnati greatly benefited the venture. Latonia became as much identified with the Queen City as it was with Covington. Also during this time, many improvements were made to the track and its surroundings. In 1887, the original grandstand was destroyed

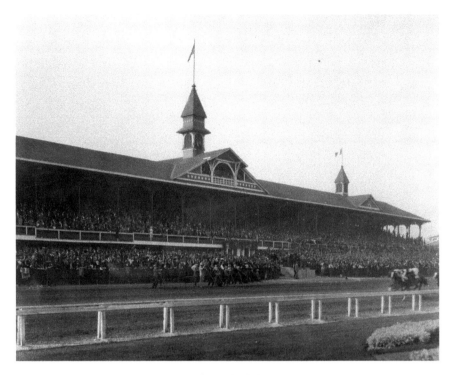

Latonia Racetrack's grandstand. *Kenton County Public Library.*

by a storm, but it was quickly replaced by a more modern structure. When the track opened, two hundred stables accommodated the horses. By the 1890s, that number had increased to seven hundred, with space for one hundred bookmakers.

During these early years, African American jockeys played an important role in the development of the track. Jockeys like Isaac Murphy and others dominated as riders and often won the Latonia Derby and the Oaks. This success frequently put them at odds with the Caucasian jockeys and resulted in tension at high-stakes races.

Latonia made several contributions to the advancement of horse racing in the United States; one of the most enduring was the two-dollar bet. In May 1897, Latonia installed a line of parimutuel betting machines. In 1909, Latonia converted entirely to this system (one year after Churchill Downs). Two years later, Latonia lowered its standard parimutuel bet from five dollars to two and offered the same for place and show. This inaugurated the two-dollar bet and the across the board bet, which have become standard in American racing.

The racetrack continued to be improved with additions to the grandstand and clubhouse. The beautiful main buildings on the grounds provided a spectacular background for racing. The track itself was also fantastically maintained. The infield included a lake and bridge, manicured flower beds and impressive displays of foliage rarely seen in the area.

As the reputation of the track grew, so did the attendance. Large races began drawing well-to-do guests. One of the earliest race goers to draw national attention to the track was Alice Lee Roosevelt, daughter of President Theodore Roosevelt. Alice attended the Latonia Derby on June 3, 1905. Her presence caused a stir throughout the area and brought many to the track just to see her. Other dignitaries also attended races at Latonia over the years, including celebrities and political leaders. Latonia Racetrack became the place to see and be seen in the region.

During the Progressive Era, reformers took aim at closing down racetracks and eliminating betting. The number of tracks in the country declined from over three hundred in 1897 to twenty-five in 1908. Latonia weathered the storm primarily due to the long tradition of horse racing in Kentucky. Kentuckians had grown accustomed to the annual rites and were not willing

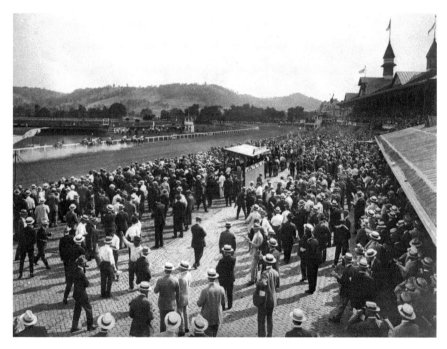

Large crowds attended the Latonia Racetrack. Notice the horses approaching the finish line on the left and the grandstand on the right. *Kenton County Public Library*.

Another view of the beautiful grounds and two-story gazebo. *Kenton County Public Library.*

to give them up. The decreasing number of tracks in the nation in the long run helped Latonia increase its purses and thus its profitability.

In the years just prior to World War I, the Latonia Derby had become one of the top ten races in the nation, challenging the Kentucky Derby in purse size. Matt Winn, who had interests in Latonia, was also one of the biggest promoters of the Kentucky Derby. The relationship between Latonia and Winn and his associates would ultimately result in Latonia's demise. Winn did everything possible to advocate for the Kentucky Derby. The Kentucky Jockey Club and Winn began favoring Churchill over Latonia. This was occurring at the same time as the Great Depression. Purses were declining, and the number of people willing to gamble, or who had the means to gamble, was also diminishing.

The Latonia Racetrack began losing money in the 1930s. In 1937, Winn announced that Churchill and Latonia would merge under the name Churchill Downs–Latonia Inc. During the following year, Latonia played host to its most prestigious guests. On July 8, 1938, President Franklin D. Roosevelt addressed a large crowd at the track to support the senatorial candidacy of Kentuckian Alben W. Barkley. The address received regional and national attention and was one of the last truly large events at the course.

Latonia Racetrack never bounced back from Matt Winn's negative attention. On July 29, 1939, the last race was held at Latonia. Winn would later announce that the track was closing. In 1942, the property was sold to the Latonia Refining Corporation. The grandstand and many of the other buildings were quickly demolished. Some of the stables remained and were used for other purposes. The track was plowed under and the once beautiful lake filled in. The beautifully landscaped track was transformed to an industrial complex. Latonia Racetrack, once the pride of the community and a jewel in the national horse racing circuit, was no more.[51]

QUEEN CITY BEACH AND TACOMA PARK

The Campbell County cities of Bellevue and Dayton were once home to popular riverfront bathing beaches, dance halls and boxing rings that drew large crowds from across the region. In 1902, local newspapers began reporting on the construction of a bathing beach in Bellevue. The two major advocates were William E. Kroger of Newport and Nat C. Colter of Bellevue. The two men planned to build a family-friendly resort that would appeal to the working-class residents of the region. The plans called for a wide sandy bathing beach with boat rentals, a 150-foot clubhouse and three hundred changing rooms at the foot of Ward Avenue. Also, a veranda would be built to accommodate bands for live music. The total estimated cost was $25,000, and the name Queen City Beach was announced.

Queen City Beach opened to the public on June 10, 1902. The company had $25,000 in stock and seven investors at that time, including Kroger and Colter. The stockholders invested heavily in newspaper advertising and billed the beach as the "Atlantic City of the West." Ads also noted the pure clean water and the yards of white sand extending as far as one thousand feet from the waterline. The Queen City Beach was a success from the start and attracted large crowds of swimmers and boating enthusiasts throughout the summer. The venue also offered concerts every Tuesday, Thursday and Sunday.

Queen City Beach made money primarily through concert tickets, private parties, concessions and boat rentals. Another significant source of income was locker room sales. Customers were required to arrive in their street clothes, rent a locker and change into their swim attire. You could not enter the premises already wearing a swimsuit.

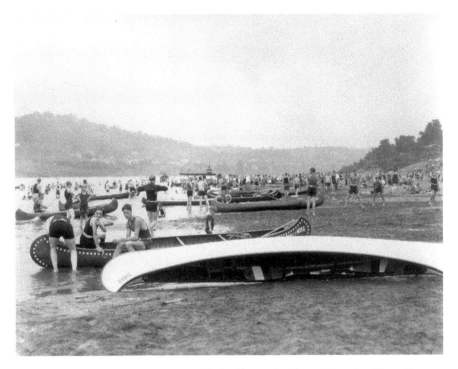

Campbell County beaches were popular for bathing, swimming and boating. *Kenton County Public Library.*

Although the beach had a few good years, it struggled to find a consistent clientele. The nearby Lagoon Amusement Park in Ludlow offered clear lake water and rides. Also, Coney Island across the river in Ohio offered more entertainment options. In May 1905, Queen City Beach was sold. The new owners kept things going for another decade, though on a smaller scale. In 1915, the property was sold again at auction.

By 1925, the Queen City Beach was back in operation under the name Riviera Beach. Accounts from the time indicated that the facilities included a large dance hall with a stage that could accommodate one thousand. The beach became less popular as more development along the Ohio River occurred. The once clear water was now being contaminated by raw sewage being dumped into the river upstream. By the late 1920s, the dance hall became the focus of the endeavor.

Around 1928, Riviera Beach became known as Horseshoe Gardens and was being operated by Edward and Agnes Rohrer. The new owners focused on the dance hall, which took on a tropical theme. A popular outdoor dining

space called the Starlight Terrace drew large crowds, as did the floating party area with the appropriate name of the Crystal Floating Palace. The venue did very well for several years and drew big band acts of the time, including Fats Waller. The economic depression took its toll on the business, and by the mid-1930s, the complex was rarely being used. Finally, the 1937 flood destroyed the entire complex and what was left of the beach. Today, the Old Queen City Beach and Horseshoe Gardens are the site of the city of Bellevue's Beach Park.

The neighboring city of Dayton was home to similar recreational endeavors. Beaches like the Berlin and Manhattan were popular for many years. Tacoma Park, which began as a traditional bathing beach, proved to be the most enduring. However, as the water of the Ohio River became less desirable, business declined.

Tacoma Park owners decided bathing beaches were declining and perhaps a swimming pool would be a better investment. The Tacoma Park Pool was a popular attraction for many years. Tacoma also became more than a summer resort. Eventually, a large boxing ring was constructed on the property and drew large crowds. The circular arena offered Wednesday night fights with admission costs of fifty cents to one dollar. Typical matches were scheduled for ten rounds and featured local pugilists like Frank Guerrea of Newport and Joe Anderson of Covington. The fights came to an end with the Great Depression in 1930. Few area residents had the

Tacoma Park in Dayton eventually built a pool, which was popular for years. *Kenton County Public Library.*

disposable income to pay for a boxing match. Tacoma Park also featured dog races, wrestling matches and the ever-popular dance marathons of the era.

Eventually, the main building was destroyed by a massive fire on June 4, 1932. Fire crews from Dayton, Bellevue and Newport fought the blaze. Damage was placed at $35,000, and arson was suspected but never proven.[52]

RESIDENCES

RITCHIE HOUSE

One of the early settlers of Ludlow, Kentucky, was the Ritchie family. Casper Ritchie (1827–1908) was a native of Switzerland, and he left his homeland for the United States in 1834. He was joined by his parents, Casper Sr. and Elizabeth, and brother Jacques. They settled a year later in Cincinnati. Casper Jr. became a well-off grocer, and he bought a residence in Mount Adams. Because of his success, he was able to purchase property in Ludlow around 1860, and he constructed the "Ritchie" House the same year. The two-story house was built for $20,000, and its main entrance was covered by a cast-iron porch.[53] According to Dave Schroeder in *Life Along the Ohio River: A Sesquicentennial History of Ludlow, Kentucky*, "[T]he Ritchie Family was typical of those residing in the Ludlow area before the arrival of the railroad. Many wealthy Cincinnatians built homes in Ludlow to get away from the overcrowded and unhealthy conditions of the city." The Ritchies had seven children at the Ludlow home: Walter, Arnold, Casper, Lily, Lula, Louis and Harvey. Two maids and a house helper assisted in running the household. The longest surviving child was Lula, who lived until 1943. Schroeder added that "the luxury of the home was impressive. On the grounds were located a brick, two story building that housed the stable, a place to store the carriages, and the laundry." In 1864, an addition was added to house Casper's book collection.

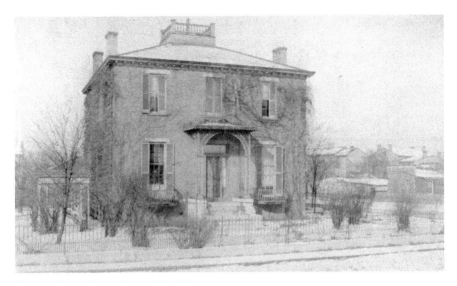

Ritchie House. *Kenton County Public Library.*

In 1958, the Ritchie House, on the northwest corner of Elm and Locust Streets, was sold to the Tea Company of Cincinnati for $84,000. It was then demolished for a new Kroger store. The Kroger store operated for many years until a new store was constructed in Fort Mitchell. Later, the building was used as an IGA Grocery store, and the site now houses several businesses.

AMOS SHINKLE MANSION

Amos Shinkle is one of the more famous historical figures in Northern Kentucky. He was born in Brown County, Ohio, on August 11, 1818, and as a teenager began working on a flatboat. He relocated to Covington around 1847 and started a successful coal business and constructed and sold steamboats. Less than ten years after relocating to Covington, he became a major stockholder in the Covington and Cincinnati Bridge Company, which financed the construction of the Roebling Suspension Bridge. In 1864, Shinkle became the president of the company. A lot of money was generated from the bridge during this time from the collection of tolls. Also involved in banking, Shinkle helped create the first national Bank of Covington in 1864 and served as president of the Covington Gaslight Company. He was also a Covington City Council member from 1853 to 1866 and served on the

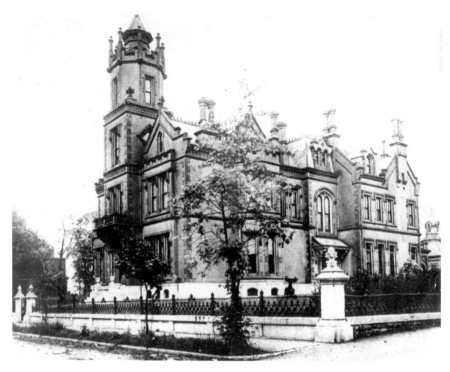

Shinkle Mansion. *Kenton County Public Library.*

Covington School Board. Out of his own pocket, Shinkle financed the first Covington Protestant Orphanage. It is now known as the Children's Home of Northern Kentucky. He was one of Covington's richest citizens.

Shinkle lived in various places over the years, including the summer home in today's Crestview Hills, Kentucky. His most famous home was constructed in 1869 and was a large Gothic Revival–style mansion on Second Street in Covington. Located in what is today the Licking-Riverside and Ohio National Historic District, the home contained thirty-three rooms and was made of white stone. This was Shinkle's main residence, and he lived there until his death on November 14, 1892. He was survived by his wife, Sarah, his son and two grandchildren. His visitation was at the mansion. Quite wealthy, Shinkle left to heirs an estate of approximately $2.5 million. Sarah lived until 1908 and died at the Second Street mansion. Following her death, the Shinkle's son, Bradford, and his family lived in the mansion until 1914. The mansion was then donated to the Salvation Army to be used as a women's home. At the time of the donation, the mansion had electric lighting, furnace heat, hot water and a lawn fountain. Title

was transferred on June 8, 1914. The organization received a mansion with woodwork that rivaled the "palaces of England," according to the Salvation Army adjutant.[54] It was valued at $150,000 and was, at the time, the largest gift ever made to the Salvation Army in the United States. However, it wasn't used very long for the intended purpose. The mansion was then used as the very first Booth Memorial Hospital, also operated by the Salvation Army. In the 1920s, the beautiful mansion was demolished in order to construct a new hospital. Booth Hospital in Covington served the community until the late 1970s, and today the building houses condos.

Marion Grubbs House (Rosegate Farm)

The Marion Grubbs Farm, located on Dixie Highway (U.S. 25) between Mount Zion and Richwood Roads, is better known as the Rosegate Farm. Dixie Highway is traditionally known as the Covington-Lexington Turnpike and is now a heavily used industrial and commercial road. The Grubbs Farm was one of the few surviving farms along the turnpike. Today, it is basically an empty field.

While serving as a beautiful farm for many years, the house is best known for its infamous past. On August 17, 1943, Carl Kiger and his son, Jerry, were murdered in the house, leading to the most famous trial in Boone County history. The trial gained national exposure, and "speculation and controversy still swirl around the night Carl Kiger and his six-year old son, Jerry, died. At the center of that notorious night was Carl's fifteen year old daughter Joan, who was later placed on trial for the shooting deaths of both Carl and Jerry."[55]

In the first deed recording, Samuel McDowell sold the thousand acres to James and Joseph McDowell on August 29, 1815. The property was described as "not far from Big Bone Lick."[56] Between 1842 and 1851, Wickliff Grubbs acquired most of the land, and between 1867 and 1884, Marion Grubbs obtained the property from Grubbs's estate. A later owner, Nellie Downing, sold a small part, including the house, to Jeannie Kiger on September 30, 1941. The Kigers considered Rosegate a summer home, as Carl Kiger was a Covington city commissioner and vice-mayor. The four-bedroom home sat on twenty acres and consisted of a large lake, several barns, chicken coops and a beautiful view of the green landscape. Following the murders, Rosegate was sold at auction for about $14,000 on November 2, 1943.

Marion Grubbs House (Rosegate Farms), site of Kiger murders. *Boone County Public Library.*

According to a Kentucky Historical Resources survey of Rosegate:

The Marion Grubbs House is an excellent example of the classic I house, a symbol of prosperity on the mid-19th century landscape. Like many country houses, it evolved through a series of additions, and thus includes an interesting mixture of elements of different periods and styles; these include center gable, a common feature of post-civil war era dwellings, and the angled vestibule and sub porch, dating from the early 20th century. The house incorporates materials unusual in the local context—slate roofing and beaded siding-perhaps reflecting the affluence of the owners. The distinctive double garage, and imposing structure somewhat unexpected in the rural context, may be unique in the vicinity.

Although in excellent shape at the time of the survey, the house was demolished by its owner in the early 2000s. Perhaps more than any lost house in Boone County, the one at Rosegate is often discussed. The Kiger murders of 1943 are often studied by people today. Books and a play have been written about what transpired at the house.

Piatt's Landing

Piatt's Landing was first a Canadian trading post, established in 1780 by a fur trapper named DeHart. He was killed in 1785 by the Shawnee. It was this piece of land Robert Piatt settled in 1908. The Piatt family was important throughout the Ohio Valley region of the country. Piatt bought two hundred acres of land, and in 1814, he built a house that later became known as Winfield Cottage. This significant house served as home to the Piatts and others throughout the years.

Robert Piatt was the nephew of Jacob Piatt, who built the magnificent Federal Hall near Petersburg. Operating a ferry from the Piatt's Landing site, Robert shipped his goods up and down the Ohio River. During the War of 1812, Robert and his cousin John supplied the troops under a contract with the army. Robert was commissioned a major in the Quartermaster Department.[57] Robert Piatt was the grandfather of Civil War general Edward Canby.

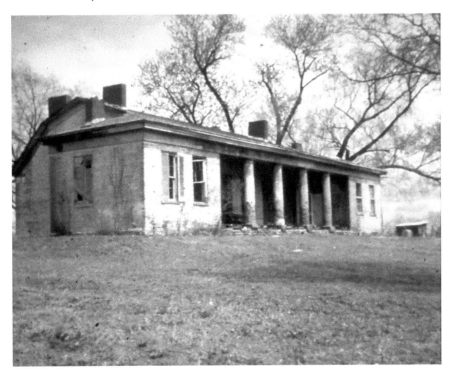

Winfield Cottage, Piatt's Landing. *Boone County Public Library*.

The house Robert built was of the Greek Revival style. It was named Winfield Cottage by the second owners of the property. According to notes by Jane Piatt Bottorff Holmes, arranged by Katherine Piatt Bottorff,

> He [Robert] *built a large brick house close to the river bank and laid out the grounds so that the place became a Mecca for visitors who came to enjoy the hospitality so freely offered and also to admire the flowers and plants grown in our great grandmother's garden. It is told that she had medicinal herbs enough to keep the whole plantation in teas and salves and as doctors were very scarce—she was physician by proxy to the whole neighborhood. When steamboats began to pass up and down the Ohio Major Robert established a wood yard where he supplied cordwood to boats. When the steamers would land to take on wood, the passengers would be escorted up to the "big house" and taken to see the gardens and orchards and returned to the steamers loaded with fruit and flowers.*

Perhaps the most significant occurrence on the property was the birth of General Canby. According to the historical marker near the site, "Brevet Maj. Gen. Edward Richard Sprigg Canby was born, November 9, 1817. A West Point graduate, in 1839, he accepted the final surrender of the Confederacy from Generals Richard Taylor and Kirby Smith in Alabama and Louisiana in May 1865. He was killed in California at a peace conference with Modoc Indians, April 11, 1873."

According to one Library of Congress document, the

> *house appears to have been built in three stages: the central area, which was the first of the three stages was a brick story and a half, containing seven rooms, four on the first and three on the second. It had a gambrel roof with three dormers front and back and stepped parapet end walls. The second stage was the addition of the portico and the east and west rooms. The third stage was the addition of the northeast structure which contained two rooms and a cellar.*

Longtime Boone County resident Pat Raverty recalled his visits to the house before it was demolished:

> *Fortunately, I had the privilege of touring Winnfield Cottage at Piatt's Landing a number of times before its demise. I was taken with its twelve-*

inch-thick brick walls that had been white washed and a cool recessed porch that took advantage of the stunning view of the Ohio River. The house had four chimneys and fireplaces, and over time two additions were added. It was a most impressive structure.

The house was demolished in the early 1970s and located near what is today the East Bend Power Plant in rural Boone County.

INTERNAL REVENUE SITE

Most residents of Greater Cincinnati know where the Covington Internal Revenue Service (IRS) Center complex is located. Designed by architect Carl Bankemper, the edifice stands on a twenty-three-acre site along Fourth Street. Construction on the building began in 1965 and was completed two years later. The official dedication took place in August 1967. The building cost $4.5 million to complete. According to author Dave Schroeder, "[T]he building came at a very opportune time for Covington. The city was suffering financially as many residents and businesses had left the community for the suburbs. The influx of IRS employees brought new revenue to the city coffers and helped a number of existing nearby businesses remain open." Congressman Brent Spence is widely regarded as the individual who made the location of this center to Covington happen.

The most interesting aspect of the site is what was located there before the IRS built its sprawling complex—a well-developed neighborhood. In fact, the residential area was pretty much completely occupied by the 1880s. It was an immigrant community and, by the time of its destruction, housed second and third generations. In an article for *Northern Kentucky Magazine*, Schroeder described the neighborhood:

> [T]he streets were lined with densely packed one and two story red brick homes and businesses. Small grocery stores and dry goods establishments were a part of the fabric of the community. The neighborhood continued to fill in, and by the early 1900s, manufacturing plants and tobacco warehouses were also represented on the riverfront. The streets were bustling with activity and filled with multicultural families and individuals. The residents had good access to public transportation through streetcar service

Riverside Drive and Covington Buildings prior to construction of Internal Revenue Service Building. *Kenton County Public Library*.

on Madison Avenue. The neighborhood's proximity to the Ohio River and the John A. Roebling Suspension Bridge provided the population with convenient access to Cincinnati.

The neighborhood was working class, and its residents were displaced by the U.S. government buying homes for the new IRS complex. Some have argued the destruction of this neighborhood led in part to an economic downturn in the city. There were now fewer residents to visit downtown Covington businesses. Two grocery stores, Kroger and Albers, both closed during this time.[58]

Two magnificent churches were located in the neighborhood. One was the First Baptist Church, completed in 1873. Its fieldstone façade stands out in all its glory. The second church did not survive the construction of the IRS complex. It was next door to the First Baptist Church. The First Presbyterian Church was also dedicated in 1873 and "featured a 185 foot spire that became a visual point of reference for the community."[59]

The neighborhood was greatly damaged and affected by the flood of 1937. Between twelve and fifteen thousand Northern Kentuckians were forced to leave their homes, and transportation links between Covington and

Cincinnati were flooded. Most likely, all from the neighborhood were forced to evacuate. Only the C&O and Suspension Bridges were open. A permit was required to cross on the Suspension Bridge.

Today, the IRS Service Center continues to run. However, in 2016, the IRS announced its intention to close the facility in the next few years. As much as the old neighborhood was a key part of the city of Covington, today the IRS Center is a mainstay. Its loss will cost the city around 1,800 jobs. Replacing these jobs will be a real challenge for city officials, and working with the federal government on future site development is crucial to Covington's future.

MOUNT ST. MARTIN — JONES MANSION

In 1977, one of the most beautiful mansions in the region was demolished. Located on a hillside east of Thirteenth and Monmouth Streets, the Italian villa was highly visible to residents and visitors alike. Since 1889, this architectural gem had been known as Mount St. Martin as a result of the Sisters of Divine Providence occupying the mansion. Before 1889, it was known as the Jones Mansion or Castle.

Mary Keturah-Taylor was the granddaughter of General James Taylor Jr. and quite an accomplished woman. She was a writer of poetry and a scholar. On September 12, 1848, she married Thomas Laurens Jones, a lawyer. Jones later became a Kentucky legislator and a member of the U.S. House of Representatives. He ran unsuccessfully for governor in 1883. In July 1862, Jones was arrested as a Confederate sympathizer, but he later swore an allegiance to the Union.[60] According to the *Encylopedia of Northern Kentucky*, "[W]hile on their honeymoon in Europe the newlyweds fell in love with an Italianate-style castle in England; and as the couple's wedding gift, Mary's father, Col. James Taylor III, offered to replicate the structure on a site of their choosing." They chose a beautiful wooded hillside in an area of Newport known as Newport Highlands. Today the site is at the intersection of U.S. 27 and Carothers Road.

The Jones mansion was designed by architect Robert A. Love. The result was a twenty-two-room mansion of gray brick with twin towers. Construction began in 1851, and the family moved in two years later. A description of the mansion helps capture its grandeur:

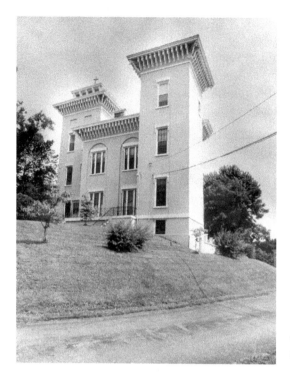

The Jones Mansion. *Kenton County Public Library.*

The completed structure comprised three sections: the two-story central section featured four triple sectioned windows set in arched, recessed panels, and was flanked on either side by two four-story towers with tall, narrow, one-over-one windows. The northwest tower, the taller of the two, was surmounted by a four-sided belvedere and enclosed the building's stunning mahogany spiral staircase; it's seventy steps led to a unique, windowless room with a circular, balustrade opening in the ceiling and a side stairway by which the belvedere and its spectacular, full-circle view of the surrounding area could be accessed.

The interior included "marble and tile floors, ornate ceilings festooned with decorative plasterwork such as molded fruits, acanthus, and garlands; several hand carved fireplaces; and rare red Bohemian glass transoms above the stair hall's main entry doors."[61]

Magnificent parties and social events occurred over the years the Joneses owned the Mansion. These included parties for political figures, socially prominent individuals and literary dignitaries.[62]

Upon the death of Thomas Jones on July 20, 1887, Mary moved to another location in Newport, and in 1889, she sold the house to the Diocese of Covington. Today a shopping center sits on the partially leveled hillside that once held the Jones Mansion.

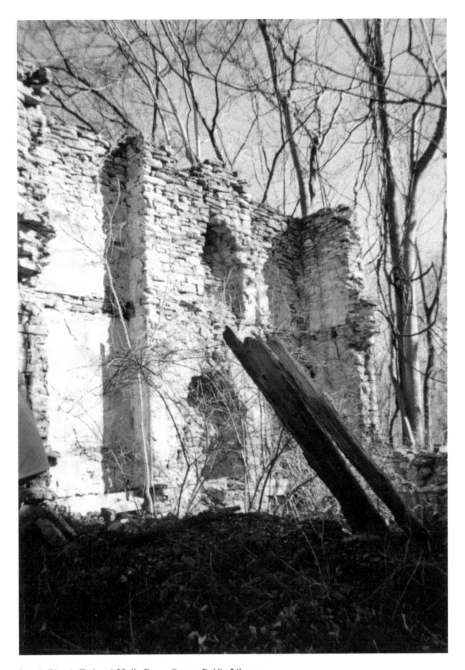

Jacob Piatt's Federal Hall. *Boone County Public Library.*

FEDERAL HALL

John and Frances Piatt immigrated to America in the 1700s, and their five children were John Jr., Daniel, Abraham, William and Jacob. All joined the Continental army during the Revolutionary War. Jacob Piatt was the uncle of Robert Piatt, who built Winfield Cottage at East Bend. Jacob served with George Washington in the Revolutionary War and was an officer of the First New Jersey Regiment. He entered the army in 1775 and fought in many battles. He was married in 1779 to Hannah Cook McCullough.

Following the Revolutionary War, Jacob Piatt moved to Cincinnati in 1795 and in 1799 to Boone County, Kentucky. He became a colonel. Jacob and his wife settled on 510 acres of land on a hilltop overlooking the Ohio River. Some say he utilized his military land grant to settle in Kentucky.[63] Ron Buckley, the leading expert on the Federal Hall property, said evidence shows he purchased it. Piatt became a judge in Boone County and served for thirteen years. According to his Find a Grave entry, "He was the [sic] one of the first judges in the state of Kentucky to sentence a defendant to death." Piatt also was a founding member of the Society of Cincinnati.

It was on this location that Piatt built his stately Federal-style mansion, presumably in 1803 or 1804. It was called Federal Hall, and the view was spectacular. The front had a large double window facing the Ohio River. According to Ron Buckley, the house was fancy and made of stone. One extension of wood was added to the house. The outside was painted white, and inside were plaster walls. The land was farmed, producing tobacco and corn.[64] While at Federal Hall, Piatt owned slaves. In 1825, General Marquis de Lafayette visited Federal Hall, along with Colonel Zebulon Pike, the father of General Zebulon M. Pike.[65] Hannah died in 1818, and Colonel Piatt, after remarrying, died in 1834. He is buried approximately 250 feet from Federal Hall in an abandoned family cemetery. A 116-acre ferry site was 4,300 feet from the house, established in 1800 by Piatt and John Watts. A fire destroyed the vacant Federal Hall in the 1980s, and only some ruins exist today. It is located between the end of Lawrenceburg Ferry Road (South) and I-275 (North). The Piatt family owned the land until 1873, when it was sold to outside interests.

SAVED NORTHERN KENTUCKY

LINCOLN-GRANT SCHOOL

In the years following the Civil War, a freedman's school was established in Covington. Eventually, two public schools were created in Covington for African American students—one on Madison Avenue and one on Robbins Street. Jacob Price, a local African American businessman and minister, was active in the founding of the Covington schools.

William Grant, a longtime supporter of African American schools, deeded a piece of property on the south side of Seventh Street between Madison and Scott Streets for a more permanent structure. The Covington School Board approved the construction of a combined elementary and high school on this site. The substantial three-story brick building featured a bell tower and decorative pediment. The building was completed in 1888 at the cost of $16,840. At that time, a little over three hundred African American children were enrolled in the school. Over the years, the school was called the William Grant School, the Lincoln School, Lincoln-Grant School or simply the Seventh Street School.

The building served the community well for decades, but by 1920, it had reached capacity and was considered unsafe. In March of that year, members of the Negro Civic Betterment League appeared before the Covington School Board asking for improvements. The third floor of the building was closed in 1923 due to the lack of fire escapes. Several classes

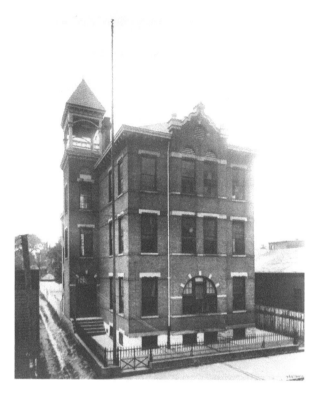

Left: Covington's Seventh Street Colored School, built in 1888. *Kenton County Public Library*.

Below: The new Lincoln-Grant School on Greenup Street, now the Covington Scholar House. *Kenton County Public Library*.

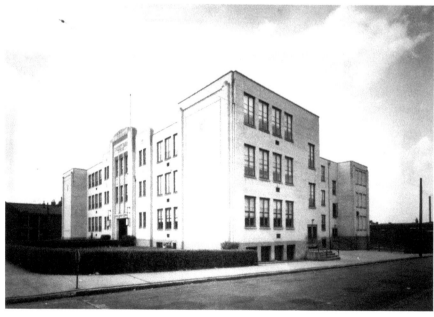

had to be moved to an annex on Sixth Street, and the third and fourth grade classes were reduced to half-days to deal with the loss of space—thus denying many students a full education.

In November 1928, a bond issued passed by a margin of 2–1 to construct a new school to replace the overcrowded and unsafe Seventh Street School. A new site was purchased on Greenup Street at Ninth for the location of the new structure. The onset of the Great Depression and disagreements on the Covington School Board resulted in various delays. Finally, construction began, and the new three-story brick building, complete with auditorium, gymnasium, industrial arts classrooms, science labs and domestic arts classrooms, was officially dedicated on March 31 and April 1, 1932. The cost of construction amounted to $177,230.75. E.C. and G.T. Landberg designed the building in the Art Deco style.

The new school became the center of the African American community in Covington. The building was a great symbol of pride of the African American population, and the educational achievements of the student body were exceptional. The new Lincoln-Grant School flourished for decades.

Changes however, were coming to the nation and Covington. The *Brown vs. Board of Education* decision of 1954 struck down the claims of separate but equal in public institutions. During the 1956–57 school year, African American children were given the choice to attend either the school closest to their homes or to remain at Lincoln-Grant. In 1965, the William Grant High School program was discontinued, and all the students were transferred to Holmes High School. In the late 1960s, the Lincoln-Grant School was renamed Twelfth District School. The school building was eventually closed in 1976. In time, the building was purchased by the Northern Kentucky Community Center and opened as the William H. Martin III Northern Kentucky Community Center. The community center thrived for many years but eventually suffered due to management issues and the lack of funding. The once beautiful building deteriorated over time and was eventually closed and left vacant.

Over the years, plans emerged to restore the old school for community and commercial purposes. In 2013, Florence Tandy of the Northern Kentucky Community Action Commission announced that the building, which had been recently placed in the National Register of Historic Places, would be transformed into the Covington Scholar House—a program that provides housing and a variety of support services for single parents who are attending college.

With the support of grants and private donations, the project got underway. Ground was broken in January 2016 on a building that would house nearly fifty apartments, study space, childcare facilities and office space. The completed structure opened in 2017 and filled almost immediately. The old school building was saved and is being used again to promote and support education in the region.[66]

ERLANGER RAILROAD DEPOT

The preservation of Erlanger's historic railroad depot can be traced back to the founding of the Erlanger Historical Society in 1990 in the home of Paul and Patricia Hahn. The new group was planning for the centennial of the city. The newly formed society soon discovered that the Erlanger railroad depot was to be demolished in the near future. Realizing the loss of the structure would also be a great loss to the history of the community, the group determined themselves to save the structure.

Following much effort, the society convinced the Cincinnati, New Orleans and Texas Pacific Railroad (CNO&TP) to donate the depot to the city on February 27, 1992. The venerable frame depot had been constructed in 1877 and, at the time of the donation, was the only frame depot on the line still standing between Ludlow and Chattanooga.

One complication of the gift was that the depot had to be moved one hundred feet into a nearby park. Fortunately, in August 1992, the society was able to secure a $10,000 grant from the Kentucky Bicentennial Commission to help with the move. In addition, the society raised a significant number of private donations to ensure the structure would be saved. Several local businesses also donated their time and resources. The building was successfully moved on rollers by the Edwards Moving Company of Louisville.

Needed renovations to the structure were extensive, including a new electrical and plumbing system. Work had to stop in 1994 due to the lack of funds. The society and community persisted and were able to raise additional funds to proceed with the project. On April 13, 1996, the depot was open to the public with several displays of the history of the city and the role the railroad played in its early development. Many of the documents and items on display were donated by the city and area residents.

The first Erlanger Heritage Days was held in September 20, 1992, in the Railroad Park, with the depot as a focal point. Heritage Days has

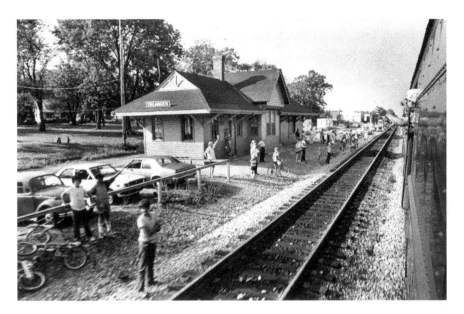

The Erlanger railroad depot in its original location before being moved to the adjacent park. Now the Erlanger Historical Society Museum. *Kenton County Public Library*.

become a well-attended yearly fixture in the community. As a result of the dedicated work of the Erlanger Historical Society, area businesses and citizens, the wonderful old depot was saved and put to use as a community asset. The depot is visited by thousands each year to learn more about the city's history and the people who have lived there. It is an excellent example of how history can be saved through public and private partnerships.[67]

GAINES TAVERN

The Abner Gaines home has been a fixture in the city of Walton since the 1800s. As early as 1800, Gaines had built a tavern along the Lexington and Covington Turnpike. As his business grew, he built a Federal-style home next door sometime between 1808 and 1814. This home not only provided living space for the family but also became a stagecoach stop on the turnpike. The two-story brick house has a central door flanked by three windows on each side. The upper floor contains seven windows—the one additional window being placed over the main entry. In 1819, a frame

addition was made to the rear to accommodate the stagecoach business. The building contains eighteen rooms.

The Gaines family were prominent in Boone County and, over the decades, held positions as the sheriff, postmaster and politicians. One member, John Pendleton Gaines, served in Congress and was later the territorial governor of Oregon.

Four generations of the family lived in the home. The Gaines family were Southern sympathizers and owned slaves, some of whom also lived in the home. Margaret Garner, a famous slave who has had several books written about her and a major motion picture made about her life, was believed to have been born on this property in 1823. Margaret, her husband and four children escaped from the property in 1856 and were able to successfully cross the Ohio River to freedom. The family, however, were found in Cincinnati and returned to Boone County. Before surrendering herself, Margaret killed their youngest child rather than send her back to slavery.

The Gaines family sold the home after the Civil War. It was purchased by John Gault in 1937. Gault accumulated a very large antique collection

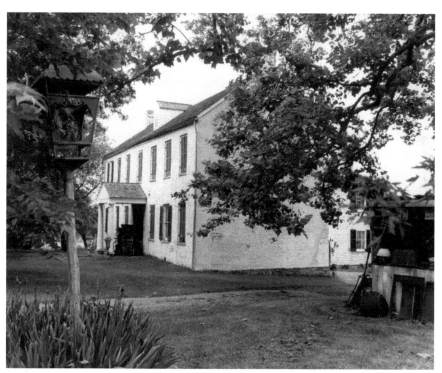

The Gaines Tavern near Walton in Boone County, 1967. *Kenton County Public Library.*

that filled the space. The property fell into decay over the years and was literally falling apart when it has purchased by Stephanie and Alan Gjerde around 1990. The couple and their two children moved into the home and began restoration work. Only four rooms were habitable at the time. Prior to this purchase, various owners had considered demolishing the historic structure.

In 2006, the City of Walton successfully applied for a $300,000 Transportation Enhancement Grant to purchase the house from the Gjerde family and turn it into a museum. By that time, the house had been listed in the National Register of Historic Places and included some original woodwork details and nine original mantels. It was estimated that an additional $350,000 would be needed to restore the home to its original beauty and to make it safe for a modern house museum. The home was eventually open to the public for exhibits and tours; however, the cost for complete restoration remained staggering. Currently, the City of Walton is making plans to ensure the structure is preserved for future generations.

Historians have confirmed six deaths in the home, one being a suicide and one a murder. Two confirmed deaths, one being a lynching, occurred outside the home. As a result, many believe the home is haunted, and multiple people have made claims of strange incidents inside the home and on the property.[68]

La Salette Academy

Covington's first Roman Catholic bishop, George Aloysius Carrell, SJ, arrived in the city in 1853. One of his primary goals was to acquire religious women to teach in the Cathedral parish school and to start an academy for young ladies. In 1855, the bishop requested the Sisters of Charity of Nazareth, Kentucky, to send a group to Covington.

In 1856, Mother Catherine Spalding, SCN, agreed to send sisters to Covington. Bishop Carrell requested the sisters open a parish school for poor children and an academy for those parishioners and non-parishioners who preferred a more advanced education for their children. At first the sisters resisted opening an academy. Bishop Carrell insisted that a tuition academy be established. He feared the parish school could not support itself and that tuition would provide the necessary funds to keep the parish school open to all. The final agreement between Bishop Carrell and the sisters called for the

establishment of a parish school for the cathedral and an academy. Bishop Carrell personally named the new academy Our Lady of La Salette.

A small two-story brick building containing six rooms with three additional rooms in the basement was purchased at the corner of Greenup and Seventh Streets on the commons for use as a convent and academy. Sister Clare Gardiner and five sisters arrived in Covington, and La Salette Academy began operation in 1855.

In 1879, Sister Lauretta Meagher (Maher) arrived in Covington as the fourth superior of the academy. She would remain in that position until 1911. In many ways, Sister Lauretta could be called one of the founders of La Salette Academy. When she arrived in Covington, the academy and convent were still in the old house on Seventh and Greenup Streets. Enrollment was modest, and the building was falling apart. Sister Lauretta set out to raise funds for a new building and to expand the curriculum. In the early 1880s, La Salette began offering a high school curriculum for its female students, while male students continued to be admitted through the eighth grade only. The academy was chartered by the Commonwealth of Kentucky in 1884.

With the encouragement of Bishop Camillus P. Maes, the sisters were determined to build a larger and more impressive academy. Sister Lauretta began working on plans for a new school. A large two-story brick building was constructed on the site of the original school in 1886, and the new edifice was dedicated during the following year. This building housed the sisters, the elementary grades and the high school. The new quarters allowed for an expanded curriculum and enrollment. Sister Lauretta expanded the building in 1903 with an addition of a third-floor convent. The final addition to the old academy building occurred in 1919. That year, a graceful Colonial-style porch was added to the front of the building.

La Salette Academy continued to advance through the 1920s and 1930s. On June 23, 1923, the academy was accredited by the Commonwealth of Kentucky. In 1930, the Southern Association of Colleges and Secondary Schools accredited La Salette with a class-A rating.

By the late 1920s, the sisters at La Salette began plans for a new building to house the high school program. Plans called for a two-story building with full basement just south of the 1880s building. The brick Georgian Revival-style building was designed by the firm of D.X. Murphy and Brother of Louisville, Kentucky. Construction was delayed by the Great Depression and the 1937 flood, but the new La Salette Academy was dedicated on December 27, 1939. The building was used exclusively as a high school, while the older

La Salette Academy at the corner of Seventh and Greenup Streets in Covington. Now La Salette Gardens, housing for senior citizens. *Kenton County Public Library*.

building continued to be used as a grade school for the academy and a convent for the sisters on the faculty.

By the late 1970s, La Salette Academy was struggling to survive. The sisters at La Salette closed their elementary department at the end of the 1965–66 school year to focus on the high school, which was experiencing substantial financial difficulties. The school relied on tuition to pay the bills; however, many of the students' families could not afford to pay the entire amount. Also, the Catholic population in Covington was declining, as more

and more people left the city for the suburbs. To make matters worse, the female academies, unlike the central boys' high schools, received no financial support from the diocese.

Between 1971 and 1976, the Sisters of Charity assumed a debt of $123,000 and were providing their services for free at La Salette. Word about the difficulties at La Salette became public knowledge, which resulted in further enrollment declines. For the 1976–77 school year, only 180 young women enrolled. On January 24, 1977, the Sisters of Charity of Nazareth voted to close La Salette Academy in June of that year.

Despite the closing of the academy, the Sisters of Charity worked very hard to see that the buildings would not be torn down and would be used for a worthwhile purpose. Eventually, both buildings were sold to a company that agreed to remodel them into affordable housing for senior citizens. The buildings' exteriors have remained remarkably intact and still bear the name of La Salette.[69]

BOOTH MEMORIAL HOSPITAL

A landmark in Northern Kentucky, Booth Memorial Hospital has a long and interesting history. The story begins with one of Covington's most well-known philanthropists—Amos Shinkle. In the latter half of the nineteenth century, Shinkle made a fortune in Covington on shipping, coal and real estate. He was also a principal supporter and longtime president of the Cincinnati and Covington Suspension Bridge Company, which was responsible for building the John A. Roebling Suspension Bridge across the Ohio River. He donated funds to building nearly a dozen Methodist churches in the region, including his home church, First Methodist, at the southwest corner of Greenup and Fifth Streets. Shinkle also solely funded the construction of the Covington Protestant Children's Home and began a very generous endowment for the institution.

Shinkle lived in several locations in Covington; however, his most impressive home was the castle on Second Street, which he built in 1869. This large Victorian home exhibited many styles and was one of the largest private residences in the region. Shinkle died in 1892, and the home passed to his family. Eventually, the family decided to turn over the building to a charitable institution. They approached the Salvation Army, which agreed to the gift. Initially, the house was used as a home for single mothers and homeless women.

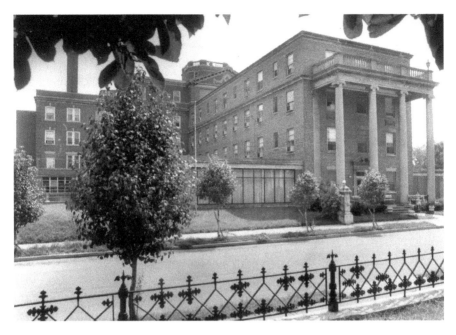

Booth Memorial Hospital. *Kenton County Public Library.*

Eventually, in 1914, the Salvation Army decided to open a hospital in the castle. The new institution was named Booth Memorial in honor of William Booth, the founder of the Salvation Army. In December of the same year, a fundraising drive was begun to make needed repairs to the home and to remodel it for medical use. Volunteers canvassed the community and raised $63,000 in a few weeks.

The hospital grew slowly, and by 1925, the need for a larger and more modern building was apparent. Dr. D. Collins Lee, a real estate developer and resident of nearby suburban Park Hills, came forward to spearhead another fundraising campaign. The campaign was a success and resulted in the construction of a new facility on the site of the old castle, which was unfortunately demolished.

Despite the new facility, the hospital struggled financially. The Great Depression made the financial conditions even worse. Booth Memorial was also in direct competition with the much more established St. Elizabeth Hospital, owned and operated by the Catholic Sisters of the Poor of St. Francis. In August 1932, officials at Booth Memorial announced the closure of the hospital due to financial shortfalls. The hope was to reopen when the national economy improved.

In January 1937, following a complete renovation of the 125-bed facility, Booth Memorial reopened just in time to deal with the 1937 flood. Flood waters inundated the basement and shut down the boiler system. The hospital stayed open and provided shelter for nearly one hundred homeless people.

As the need for more modern facilities became apparent, a wing was added to the original building in 1950 and again in 1958.

As the population of the urban core declined, so did the occupancy rate at Booth. The hospital was running deficits for many years and finding it hard to keep up with modern medical technology. Several studies called for the closing of the hospital or for its removal to the suburbs. On April 4, 1973, hospital officials announced the construction of a new Booth Memorial Hospital in Florence, Boone County. Ground for the new hospital was broken in 1977, and the facility was open for business in July 1979. Eventually, Booth Memorial was acquired by St. Luke Hospital, and eventually by St. Elizabeth Health Care.

The old Booth Memorial sat vacant on Second Street in Covington. Fortunately, the timing was right and the building was purchased by a developer who transformed the hospital into a condominium complex. The development was named Governor's Point and quickly became a sought-after residential address.[70]

MONTE CASINO CHAPEL

Monte Casino Chapel is a tiny fieldstone structure currently sitting on the edge of a picturesque pond at the entrance of Thomas More College in Crestview Hills, Kentucky. The chapel, which comfortably holds two, has become a symbol of the college and has been featured in regional and national publications as one of the smallest churches in the world.

The history of the chapel dates to the arrival of the Benedictine Fathers in Covington at St. Joseph Church in 1858. In 1877, it was brought to the attention of the Benedictines that the old winery and vineyards on Prospect Hill in Central Covington (Peaselburg), just south of Covington, were for sale. The Benedictines decided to purchase the property and produce altar and table wine as a means to finance their ministries. The seventy-six-acre plot of land was purchased for $21,500, and a group of Benedictine Brothers were brought from Latrobe, Pennsylvania, to Covington to reestablish the winery. The new monastery was named Monte Casino in honor of the

Monte Casino Chapel in its original location in Covington. *Kenton County Public Library.*

Benedictines' first foundation in Italy. Their initial efforts were profitable, and they supplied altar wine for many parishes across the Midwest.

In time, the Brothers built a U-shaped brick monastery on the hill and renovated and constructed several outbuildings to press and store the wine. The Benedictines lived by a rule that called for periods of prayer and work—"ora et labora." In 1901, under the direction of Brother Albert Soltis, OSB, the six brothers began stockpiling fieldstone on a site near the vineyards. Here, Brother Soltis built a small chapel measuring six by nine feet. At the back

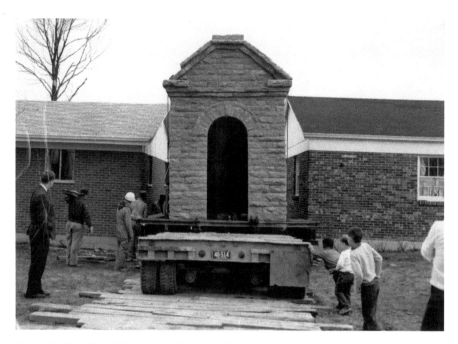

Monte Casino Chapel being moved from Covington to Thomas More College in 1965.
Kenton County Public Library.

of the chapel, they built a small altar, which held a statue of the Pieta, a depiction of the Virgin Mary holding her son Jesus after the crucifixion. The chapel contained several small stained-glass windows and kneelers. Over the door in the German language was written "There is no sorrow like my sorrow." The brothers used the chapel for private prayer and devotion.

The vineyards ceased operation—primarily because of Prohibition—until 1922, when the property was leased to a local resident. Although the brothers could still produce sacramental wine for churches, they could not sell table wine. The brothers returned to Latrobe, and Monte Casino Chapel remained as a reminder of their labor on the hill.

The chapel remained on the site for another forty-three years. Unfortunately, during this time, fires were lit inside the building, and the stained glass and other items were damaged or destroyed. Frederick Riedinger purchased all the monastery land in 1957. He sold all the property, except the tiny chapel, to the Hanser Home Company in 1960. This company built a subdivision on the property. Two of the streets bear the names Monte and Casino.

When Villa Madonna College (now Thomas More College) moved from Covington to suburban Crestview Hills, Frederick Riedinger decided to

offer the college the old fieldstone chapel in memory of his mother. The college agreed to the offer. However, moving the forty-ton structure proved problematic. The stone steeple was removed, and the building was lifted by jacks and placed on a large flatbed trailer. The trailer barely fit through the side yard of the two newly built homes on the property. The chapel was then slowly taken up the hill to the Dixie Highway and Turkeyfoot Road to the new college site. Finally, it was set into place near the pond.

Monsignor John F. Murphy, president of the college, and the board of trustees committed the funds to restore the chapel, including new stained-glass windows and repairs to the steeple and altar. The chapel has become a popular location for contemplation, feeding ducks on the pond and wedding photographs. Over one hundred years old, the tiny Monte Casino Chapel still receives attention and interest and fulfills the initial purpose as designed by Brother Albert Soltis, OSB, in 1901.[71]

LUDLOW CHRISTIAN CHURCH

One of earliest and most influential organizations in the city of Ludlow was the Christian Church (Disciples of Christ). The two men who nurtured the congregation at the beginning were J. Glaspohl and James Downey. Services were being held as early as 1840. In the 1840s, a two-story brick church was constructed at the southeast corner of Elm and Locust Streets. Congregation lore indicates that the property was donated to the church by Helen Ludlow in thanksgiving for the conversion of one of her sons. The lower level of the building was used for classroom and meeting space and the upper level for worship services.

The Ludlow Christian Church played a prominent role in the early development of the city. The first city council meeting was held in the building, and the Ludlow Independent School District began educating children in the church's classrooms.

In 1893, the Ladies Aid Society was established with the primary goal of building a new church to house the growing congregation and Sunday school. In 1895, the original building was demolished to make way for a new sanctuary. The new Gothic Revival church was built between 1895 and 1896. The interesting building included a square sanctuary, with the pulpit and baptismal pool constructed in one of the corners. The sanctuary could seat 250. The pews radiated in a semicircular pattern. A large hall off the back of the building could be used for expanded worship space, as the hall

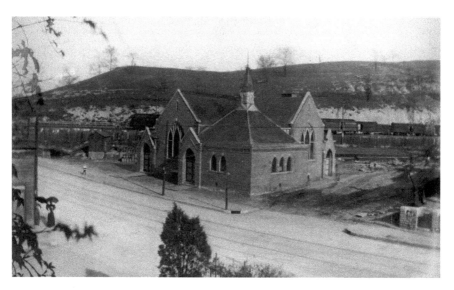

Ludlow Christian Church soon after its completion in 1896. *Kenton County Public Library*.

and the sanctuary were divided by a set of ingenious sliding doors. When these doors were open, the sanctuary seating area could be increased to 450. The building also contained multiple Sunday school classrooms. The new church, topped by a graceful spire, was dedicated on January 19, 1896.

Like many older city churches, Ludlow Christian experienced declining membership beginning in the 1970s. By 2005, attendance had dropped to fewer than twenty, and the church was officially closed. The congregation desired that the building remain standing and be put to a good community use. Members approached Mayor Ed Schroeder and asked if the city would be interested in the building. At the same time, the city had been planning to find a suitable location to house the city offices, council chambers and police department under one roof. As a result, the congregation sold the building to the city at a very low cost. Mayor Schroeder, City Administrator Brian Dehner and State Representative Arnold Simpson were able to find grant money to help remodel the building. The church was purchased by the city in 2007 and, following a complete renovation, was dedicated as the Ludlow Administrative Center on October 29, 2008. The former sanctuary was named the Ed F. Schroeder Council Chambers in honor of the mayor's service to the community. As a result, one of Ludlow's most historic structures was saved and readapted for public use.[72]

NOTES

Chapter 1

1. Purves et al, *Newport, Kentucky*, 27–71.
2. Tenkotte and Claypool, *Encyclopedia of Northern Kentucky*.
3. *Bulletin of the Kenton County Historical Society* (July/August 2006).
4. Ibid.
5. "Beverly Hills Supper Club Fire," Wikipedia, last modified February 28, 2018, https://en.wikipedia.org/wiki/Beverly_Hills_Supper_Club_fire.
6. *Cincinnati Enquirer*, May 25, 1997.
7. Norm Clarke, "Reporter Recalls 1977 Beverly Hills Fire," Cincinnati, June 8, 2014, https://www.cincinnati.com/story/news/2014/06/08/reporter-recalls-beverly-hills-fire/10192417.
8. *Cincinnati Enquirer*, May 25, 1997.
9. *Beverly Hills Supper Club Fire*, Center for Fire Research, United States National Bureau of Standards, 93–113.
10. *Cincinnati Enquirer*, May 25, 1997.
11. Dunham, *Covington, Kentucky*, 64.
12. "Liberty Theater," Cinema Treasures, http://cinematreasures.org/theaters/9913.
13. Schrage, *Legendary Locals of Covington*, 9.
14. Webster, *History of Northern Kentucky*, 8.
15. Ibid., 32.
16. Striker, *Lost River Towns*, 60.

17. Tenkotte and Claypool, *Encyclopedia of Northern Kentucky*, 713.
18. Ibid.
19. Schroeder, *Life Along the Ohio*, 42.
20. Kentucky State Parks, http://parks.ky.gov.
21. Hillary Delaney, interview with the author, March 27, 2017.
22. *Louisville Courier Journal*, November 19, 1899.

Chapter 2

23. Tenkotte, *Heritage of Art*, 31, 64–65; *Kentucky Post*, October 30, 1914, 1; November 11, 1930, 1.
24. *Kentucky Post*, February 8, 1909, 2; November 24, 1914, 1; May 2, 1922, 1; March 19, 1932, 3; May 20, 1932, 1; *St. Paul Evangelical Church*.
25. Tenkotte, *Heritage of*, 43–49; *Licking Valley Register*, July 8, 1843, 1; April 1, 1895, 2; May 18, 1896, 5.
26. *Madison Avenue Presbyterian Church*; *Dedication Booklet of Lakeside*.
27. *St. Aloysius Church*; Ryan, *History of the Diocese*; *Messenger*, April 25, 1949, 1; *Kentucky Post*, February 15, 1915, 1; February 26, 1915, 1; March 25, 1976; May 18, 1985, 1.
28. *St. Patrick Church*; *Diamond Jubilee*; *Kentucky Post*, August 21, 1897, 5; November 29, 1913, 2; September 25, 1922, 1.
29. *St. Joseph Church*; *Historic Sketch*; Springer, *Nineteenth Century German American*; *Kentucky Post*, March 7, 1916, 1; October 5, 1970; *Daily Commonwealth*, October 28, 1877, 4; November 5, 1877, 4.
30. Tenkotte, *Heritage of Art*, 36–39. *100th Anniversary*.
31. Ryan, *History of the Diocese*.
32. Lassetter, *Covington Schule*; *Kentucky Post*, January 9, 1915; November 29, 1915, 1; *Kentucky Times-Star*, March 18, 1939, 2; *Kentucky Enquirer*, February 1, 2006, 1c.

Chapter 3

33. Dunham, *Covington, Kentucky*, 40.
34. Reis, *Pieces of the Past*, 83.
35. Ibid.
36. Dunham, *Covington, Kentucky*, 85.
37. Schroeder, "Our Rich History."

38. "Daniel Henry Holmes," Nkyviews, http://www.nkyviews.com/kenton/text/holmes_the_man.html.

39. Tenkotte and Claypool, *Encyclopedia of Northern Kentucky*, 454.

40. "United States Courthouse and Post Office," Kenton County Library, https://www.kentonlibrary.org/genealogy/regional-history/covington/downtown/united-states-courthouse-and-post-office.

41. "Bygone Buildings: Covington's Changing Cityscape," Kenton County Library, https://www.kentonlibrary.org/2014/bygone-buildings-covingtons-changing-cityscape.

42. *Campbell County, Kentucky*, 112.

43. Tenkotte and Claypool, *Encyclopedia of Northern Kentucky*, 847

44. *Campbell County, Kentucky*, 123.

45. Ibid., 121.

46. Tenkotte and Claypool, *Encyclopedia of Northern Kentucky*, 627.

47. "Burlington Schools," Nkyviews, http://www.nkyviews.com/boone/boone_burlington_schools.htm.

48. Clore, "Morgan Academy."

49. Ibid.

Chapter 4

50. Schroeder, *Life Along the Ohio*, 95–119.

51. Claypool, "Old Latonia Racetrack," 1–13.

52. *Kentucky Post*, June 12, 2000, 4k; April 22, 2002, 4k; July 18, 2005, 4k; April 25, 2007, A6.

Chapter 5

53. Schroeder, *Life Along the Ohio*, 17–18.

54. Boh, "Amos Shinkle Estate."

55. Schrage, *Carl Kiger*.

56. Kentucky Historic Resources Individual Survey Form, 10637 Dixie Highway.

57. Striker, *Lost River Towns*, 95.

58. Tenkotte and Schroeder, *Gateway City*, 196.

59. Schroeder, "Could the Past of the IRS Center Hold the Key to the Neighborhood's Future?"

60. Tenkotte and Claypool, *Encyclopedia of Northern Kentucky*, 634.

61. Ibid.

62. Ibid.

63. Striker, *Lost River Towns*, 57.

64. Ron Buckley presentation at Boone County Public Library (2015).

65. "Col Jacob Piatt," Find a Grave, https://www.findagrave.com/memorial/64920061/jacob-piatt.

Chapter 6

66. Hampton, *Leaving Children Behind*, 29, 60–61, 67, 86–87; *Kentucky Enquirer*, September 14, 2013, 1; January 27, 2016, A13.

67. Onkst, *From Buffalo Trails to the Twenty-First Century*, 136–37; *Kentucky Post*, August 27, 1992, 1k.

68. "Haunted Gaines Tavern Ghost Walk," produced by the staff of the Boone County Public Library, October 20, 2012; *Kentucky Post*, December 26, 2000, 8k; April 24, 2006, A1; July 4, 2006, A2; January 8, 2007, A2.

69. Schroeder, "Love of Christ."

70. Reis, *Pieces of the Past*, 215–16.

71. *Bulletin of the Kenton County, Kentucky Historical Society*, October 1999.

72. Schroeder, *Life Along the Ohio*, 21–23, 66, 214–15.

BIBLIOGRAPHY

Becher, Matthew. *History of the 1889 Boone County Courthouse, Boone County, Kentucky*. 2008.

Boh, John. "The Amos Shinkle Estate." *Bulletin of Kenton County Historical Society* (Winter 1986–87).

Campbell County, Kentucky, 200 Years: 1794–1994. Alexandria, KY: Campbell County Historical Society, 1994.

Claypool, James C. "Old Latonia Racetrack." *Northern Kentucky Heritage Magazine* 6, no. 1, 1–13.

Clore, Zayda. "Morgan Academy of Burlington, Kentucky 1836–1894." http://www.nkyviews.com/boone/pdf/Morgan_Academy_Burlington.pdf

Dedication Booklet of Lakeside Presbyterian Church, Lakeside Park, Kentucky, 1963, collection of the Kenton County Public Library, Covington, Kentucky.

Diamond Jubilee, St. Patrick Church, Covington, Kentucky, October 12, 1947, collection of the Kenton County Public Library, Covington, Kentucky.

Dunham, Thomas. *Covington, Kentucky: A Historical Guide*. Bloomington, IN: AuthorHouse, 2007.

Hampton, Jeffrey, *Leaving Children Behind: Black Education in Covington Kentucky*. Covington, KY: Kenton County Historical Society, 2009.

Historic Sketch of St. Joseph Church, Covington, Kentucky, 1935, collection of the Kenton County.

Kentucky Historic Resources Individual Survey Form, 10637 Dixie Highway.

Lassetter, Leslie A. *Covington Schule, the Temple Israel, 1976*, collection of the Kenton County Public Library, Covington, Kentucky.

Madison Avenue Presbyterian Church Centennial, 1855–1955, Kenton County Public Library collection.

100th Anniversary of Mother of God Church, 1971. Collection of the Kenton County Public Library, Covington, Kentucky.

Onkst, Wayne, ed. *From Buffalo Trails to the Twenty-First Century: A Centennial History of Erlanger, Kentucky*. Erlanger, KY: Erlanger Historical Society, 1996.

Parochial Symphony of St. Aloysius Church 1909, collection of the Kenton County Public Library, Covington, Kentucky.

Preston, Steve, "Our Rich History: When the Army Came to Newport— the Newport Barracks and the New West." *Northern Kentucky Tribune*, November 9, 2015.

Purvis, Thomas L., Kenneth M. Clift, Betty Maddox Daniels, Elisabeth Purser Fennel and Michael E. Whitehead. *Newport, Kentucky: A Bicentennial History*. Newport, KY: Otto Zimmerman and Son, 1996.

Reis, Jim, *Pieces of the Past*. Vol. 1. Covington, KY: Kentucky Post, 1988.

Ryan, Paul. *A History of the Diocese of Covington*. Covington, KY, 1954.

Schrage, Robert. *Boone County: Then and Now*. Charleston, SC: Arcadia Publishing, 2005.

———. *Carl Kiger: The Man Beyond the Murder*. N.p.: Merlot Group, 2011.

———. *Legendary Locals of Covington*. Charleston, SC: Arcadia Publishing, 2014.

Schroeder, David E. "Could the Past of the IRS Center Hold the Key to the Neighborhood's Future?" *Northern Kentucky Magazine* (Spring 2017) http://bestofnky.com/NKY/Articles/NKY_History_5172.aspx.

———. *Life Along the Ohio: A Sesquicentennial History of Ludlow, Kentucky*. Milford, OH: Little Miami Publishing Company, 2014.

———. "The Love of Christ Impels Us: A Bicentennial History of the Sisters of Charity of Nazareth in Northern KY." *Northern Kentucky Heritage Magazine* 20, no. 1.

———. "Our Rich History: High School in Covington—Long before Holmes—Had 20 Students in 1853." *Northern KY Tribune*, January 4, 2016.

Springer, Annemarie. *Nineteenth Century German American Church Artists*. Bloomington, IN: self-published, 2001.

St. Aloysius Church, Covington, Kentucky, Diamond Jubilee Celebration, 1865–1940. Collection of the Kenton County Public Library, Covington, Kentucky.

St. Joseph Church, Covington, Kentucky, 1855–1970. collection of the Kenton County Public Library, Covington, Kentucky, collection of the Kenton County Public Library, Covington, Kentucky.

St. Patrick Church, Covington, Kentucky, 1872–1922, Golden Jubilee Celebration. Collection of the Kenton County Public Library, Covington, Kentucky.

St. Paul Evangelical Church, 75th Anniversary Booklet, 1847–1922. Collection of the Kenton County Public Library, Covington, Kentucky.

Striker, Bridget. *Lost River Towns of Boone County.* Charleston, SC: The History Press, 2010.

Tenkotte, Paul A. *A Heritage of Art and Faith: Downtown Covington Churches.* Covington, KY: Kenton County Historical Society, 1986.

Tenkotte, Paul A., and James Claypool, eds. *The Encyclopedia of Northern Kentucky.* Lexington: University Press of Kentucky, 2009.

Tenkotte, Paul A., James Claypool and David E. Schroeder, eds. *Gateway City: Covington, KY 1815–2015.* Covington, KY: Clerisy Press 2015.

Webster, Robert D. *A History of Northern Kentucky's Long-Forgotten Neighborhood Theaters.* Covington, KY: Kenton County Historical Society, 2008.

INDEX

ABOUT THE AUTHORS

ROBERT SCHRAGE is very active in local history circles and has served on the boards of the Rabbit Hash Historical Society, Boone County Historic Preservation Board and the Behringer Crawford Board. In 2015, Schrage received the William Conrad Preservation Excellence Award for Lifetime Achievement in preservation of local history. Previous works include: *Legendary Locals of Covington* (Arcadia Publishing); *Eyewitness to History: A Personal Journal* (winner of honorable mentions at the New York, Amsterdam and Florida Book Festivals, Merlot Group); *Carl Kiger: The Man Beyond the Murder* (Merlot Group); *The Ohio River from Cincinnati to Louisville* (Arcadia Publishing); *Boone County: Then and Now* (Arcadia Publishing); and *Burlington* (Arcadia Publishing).

DAVE SCHROEDER is past president of the Kentucky Library Association and the Kentucky Public Library Association. He is currently president of the Friends of the Kentucky Public Archives. He is also a longtime member of the Kentucky Archives and Records Commission. Schroeder has presented at local, state and national conferences on history and genealogy topics. He was awarded the James Nelson Advocacy Award in 2012 by the Kentucky Library Association, the 2014 Outstanding Public Library Service Award by the Kentucky Public Library Association and the Two-Headed Calf Award in History from the Behringer-Crawford Museum in Covington, Kentucky, in 2017. That same year, he was presented the Alumni Professional Achievement Award from Thomas More College in Crestview Hills,

Kentucky. Schroeder is the executive director of the Kenton County Public Library and previously held the position of archivist for Thomas More College and the Diocese of Covington. He is the author of *Life Along the Ohio: A Sesquicentennial History of Ludlow, Kentucky* (Little Miami Press, 2014) and co-editor of *Gateway City: Covington, Kentucky, 1815–2015* (Clerisy Press, 2015).

Printed in the USA
CPSIA information can be obtained
at www.ICGtesting.com
LVHW061929271123
765040LV00017B/534